Paint Watercolour

DISTILLING THE SCENE

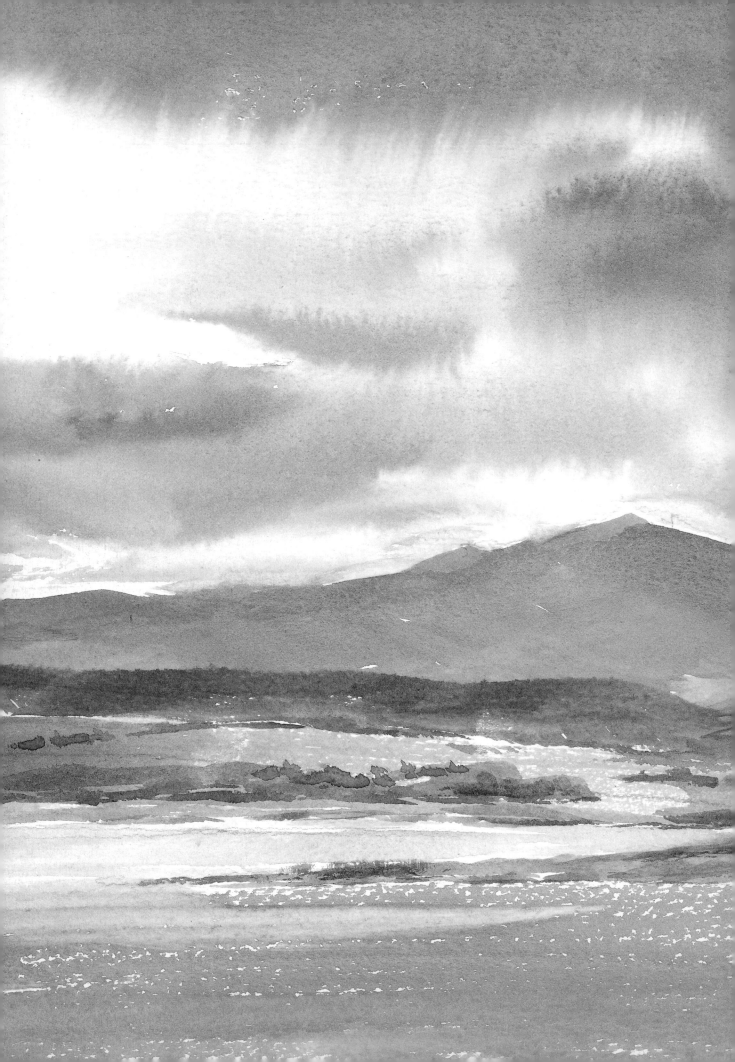

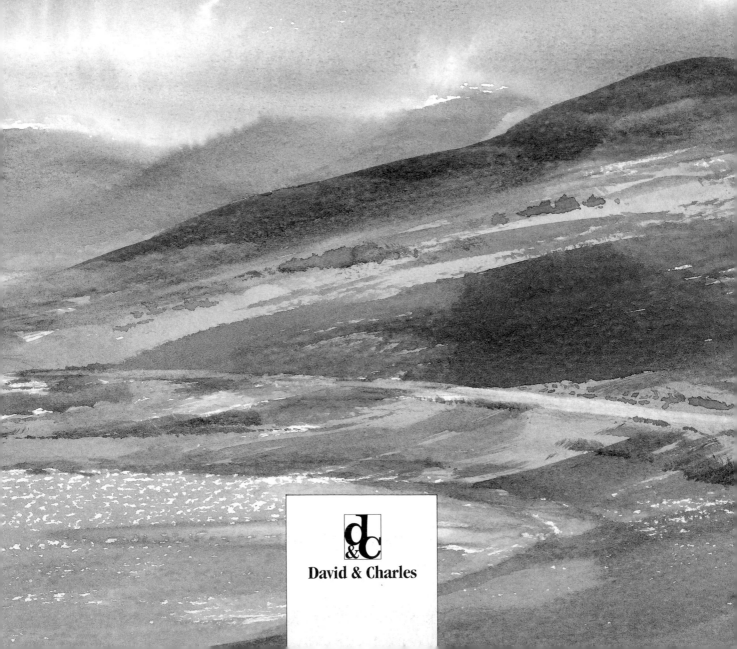

Paint Watercolour

DISTILLING THE SCENE

RON RANSON

David & Charles

A catalogue record for this book is available from the British
Library.

ISBN 0 7153 0067 9

Typeset by Ace Filmsetting Ltd, Frome
and printed in Singapore by C.S. Graphics Pte Ltd
for David & Charles
Brunel House Newton Abbot Devon

I would like to thank the following for
allowing me to reproduce some of the
pictures in this book: Norfolk Museums
Service, Norwich Castle Museum, for *Greta
Bridge* (1810) by John Sell Cotman; Rowland
Hilder's estate for *Sea Reach from Kentish Side*;
Richard Green for Edward Seago's *Foothills of
the Atlas*; Susan Mulhauser for many of her
transparencies. I would also like to thank the
following artists for allowing me to use their
work: Lawrence Goldsmith, John Palmer, John
Yardley, Frank Webb; Mrs Claude Croney and
Mrs Wesson for allowing me to use the paint-
ings by their late husbands; and Carol Hagerman
who gave me a lot of help and encouragement
with the drawing and design sections. Finally,
my thanks go to Ann Mills who helped me
enormously with the writing and Jenny Hickey
who did all the typing.

CONTENTS

INTRODUCTION

I n the past, I seem to have gained something of a reputation for specialising in encouraging people to make a start in watercolour. My courses and my books have rather concentrated on this, and my aim has been to infect would-be painters with my own enthusiasm, and to remove some of the fear and false mystique which have so often surrounded watercolour. Now I feel that it is time to move forward a little and in response to requests from my students, I am beginning to run more advanced courses. It seemed logical, therefore, to produce a book that looks beyond the elementary techniques and towards the processes of simplification, directness and design, in other words 'Distilling the Scene'.

When we look at paintings by the masters of watercolour, the simplicity of treatment appears to be very logical and easily obtainable. However, this is enormously deceptive. These results are only achieved after first mastering the materials and training the brain to analyse what is essential to the picture and what is irrelevant. For students, mastering the materials is just a question of time and practice – in other words, learn your craft. Thinking about it in tennis terms, you first learn all your strokes, practising until you can produce them instinctively without having to think about them. To progress further, however, you must learn court craft and tactics, which require a different level of intellectual effort.

In painting, at first you sit down in front of a subject and simply attempt to record it as accurately as possible. The next stage, however, is to be able to design your painting, using the elements in front of you but arranging and modifying the material to produce an infinitely more satisfying picture.

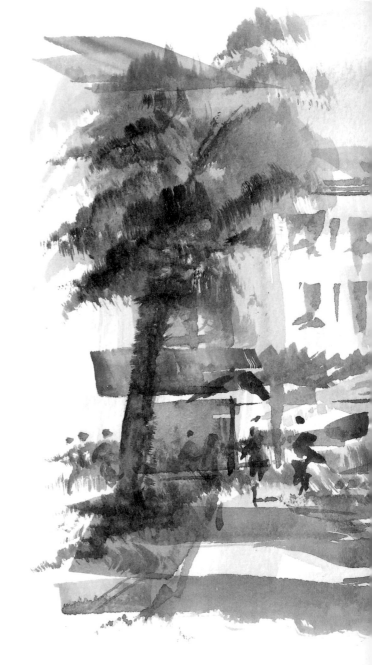

This painting was done very rapidly on one of my trips to Italy. I thought I'd try to paint it without any pre-pencil drawing at all. It's an exciting exercise which certainly sharpens the concentration and produces a more impressionistic result.

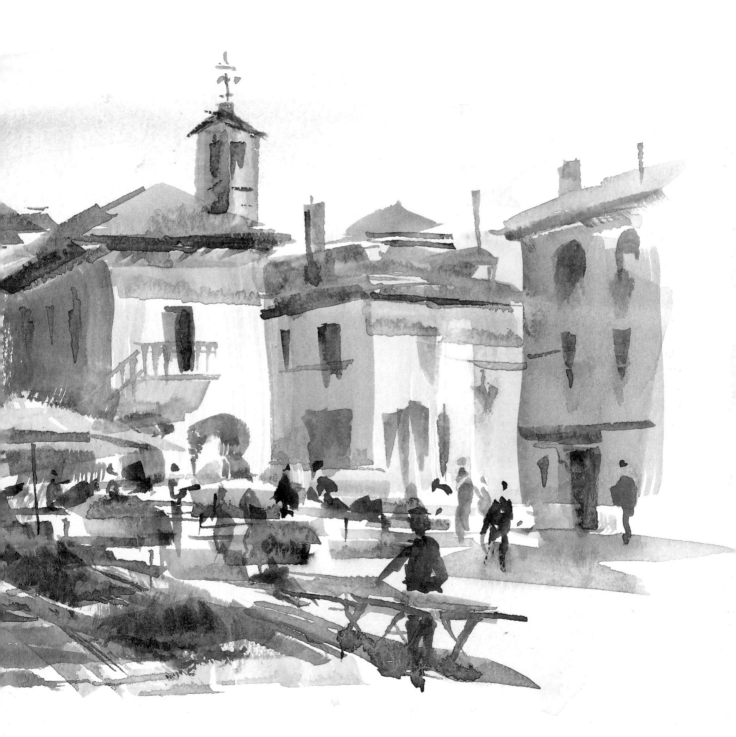

DISTILLING THE SCENE

I painted this scene during a workshop which I ran in Oregon, USA.
It's of the famous Rogue River, reputedly the finest salmon river in
the country. It's an 'S' shaped composition with the river taking the
eye to the counterchanged distant bend.

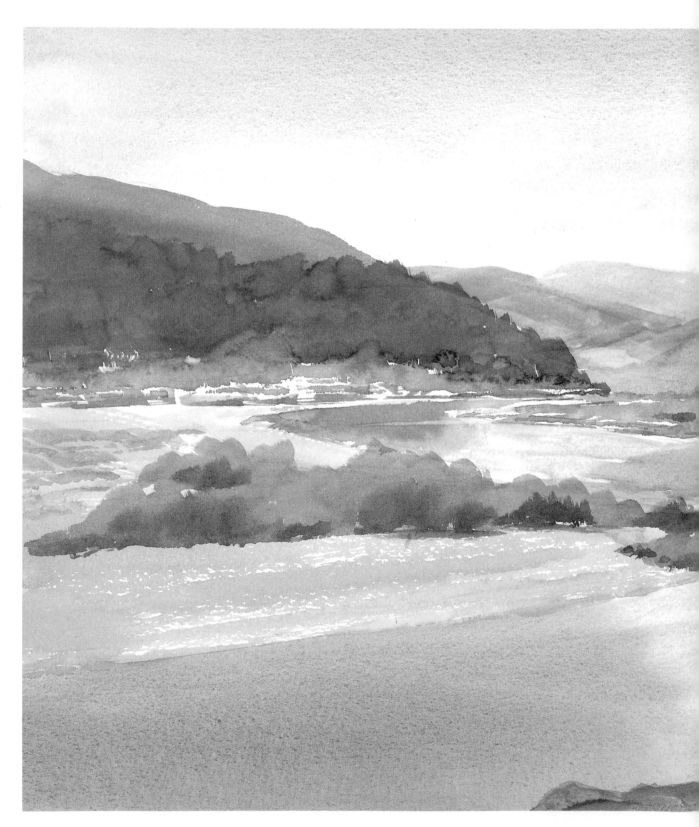

It is important to understand the meaning of design as it applies to watercolour, because until you do you're simply not going to produce worthwhile and meaningful work. A painting is not just a collection of unrelated objects but should be an interlocking and arresting whole.

The aim is to synthesise, hopefully using fewer and fewer strokes, much in the way that a good piece of poetry will convey its meaning vividly, without superfluous words.

In this book, therefore, I have assumed that you already know how to use your materials and are ready to come with me to the next stage in the most fascinating and elusive of mediums – watercolour.

Although I've been immersed in watercolour painting for about eighteen years now, painting, teaching, writing and making videos on the subject, it still thrills and excites me as much as ever. The deeper I've delved into watercolour painting, the more I realise just how much there is to learn, and this learning is far more than just putting paint on paper efficiently, which is really only the beginning. I sometimes liken watercolour to golf, telling artists that the fewer strokes they use the more professional the results will appear. Taking the analogy a stage further, you never master the game completely and always feel a tingle of anticipation at each hole, always wondering whether you're going to get into trouble or manage a hole in one. As in golf, at any stage in your watercolour career you can have periods where you seem to lose all confidence and start to think that you're never going to produce a decent painting again. I know this as I've been through a few traumatic times myself, and I've learned that the only thing to do is to keep painting doggedly until suddenly the spirit returns – and it will. When I have time, I'm going to take up golf, too!

You won't find any chapters in this book on how to put on graduated washes. I have presumed that you have already learned that – hopefully from my previous books! This book tries to take you deeper into the subject, looking at the thinking and planning which goes on before you even lift your brush – with a little homespun philosophy thrown in. You'll also find a chapter devoted to creating your own style. This personal style will inevitably evolve slowly, so don't panic. Hopefully, though, the ideas in the rest of the book will hasten the process, stimulating and encouraging you to more mental involvement, thus allowing your personality to show through in your painting.

MASTERS OF DISTILLATION

Not to make any bones about it, the five artists featured in the following pages have taught me more about distillation in watercolour than anyone else. The list could be extended, as there are many other artists whose work I admire and revere, such as John Singer Sargent who was a superb loose watercolourist. However, for the purpose of this book, the work of these five artists fits the bill admirably. The keynote which links them all is simplicity, which can only be achieved by deep knowledge. There is no short-cut to this, although it appears deceptively straightforward. To those of us who attempt to follow in the footsteps of these five masters, however, the difficulties become all too evident, and we realise quickly that the process of simplification and distillation requires keen observation, analysis and evaluation, before we even lay our brush on paper.

John Sell Cotman (1782–1842)

Here was a man who was centuries ahead of his time, his style being completely different from the work of any other artist at that time. His results were attained in a unique way by reducing his subject matter to interlocking slabs of colour which created harmony and pattern in his landscapes. Using rough paper he was able to convey texture and detail with incredible brevity of stroke and he was particularly masterful in his simplification of buildings. His churches, castles and other buildings, although so briefly indicated, were instantly recognisable and the weight and texture of the stone were always apparent. Unlike his friend Turner, Cotman's genius was not recognised during his lifetime. He was obliged to sell his pictures at very low prices and died a pauper.

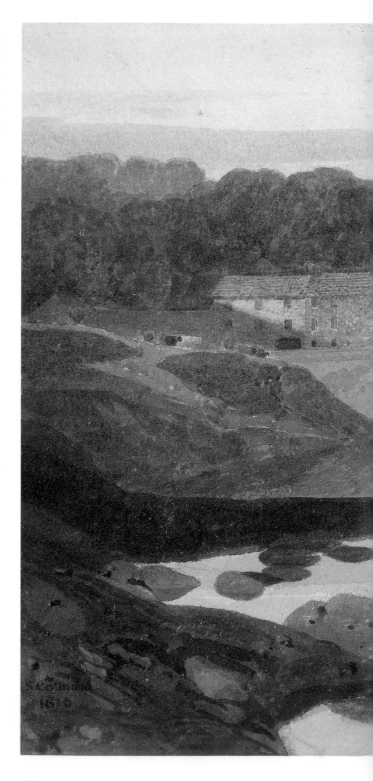

GRETA BRIDGE (1810) by John Sell Cotman

This magnificent painting of the Greta Bridge in Rokeby Park, Yorkshire, was one of Cotman's most famous paintings. The interlocking areas of colour produced a surface pattern of sheer brilliance. He has used his favourite colours of yellow ochre, sepia and burnt umber to great effect creating a unified and harmonious whole. The sky is well thought out and the cool greys and blues complement perfectly the richer colours of the landscape.

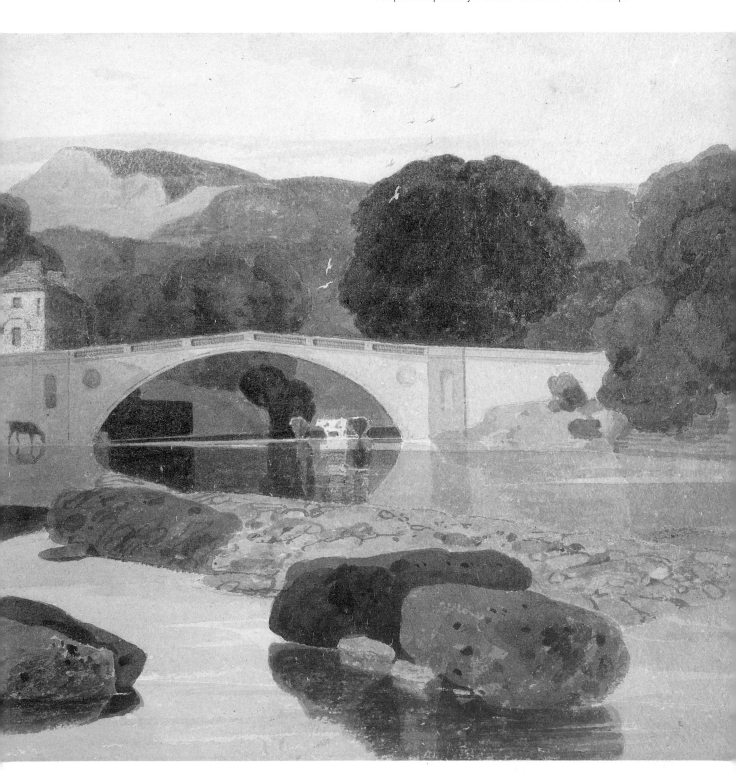

SEA REACH FROM KENTISH SIDE by Rowland Hilder

This superb painting is full of space and atmosphere. Beautifully balanced, the two main trees are echoed by the cloud shapes. Hilder uses one of his favourite techniques of putting a strong shadow along the base of the picture to take the viewer into the scene. This dark is also used to balance the trees. The handling of the sky is masterly.

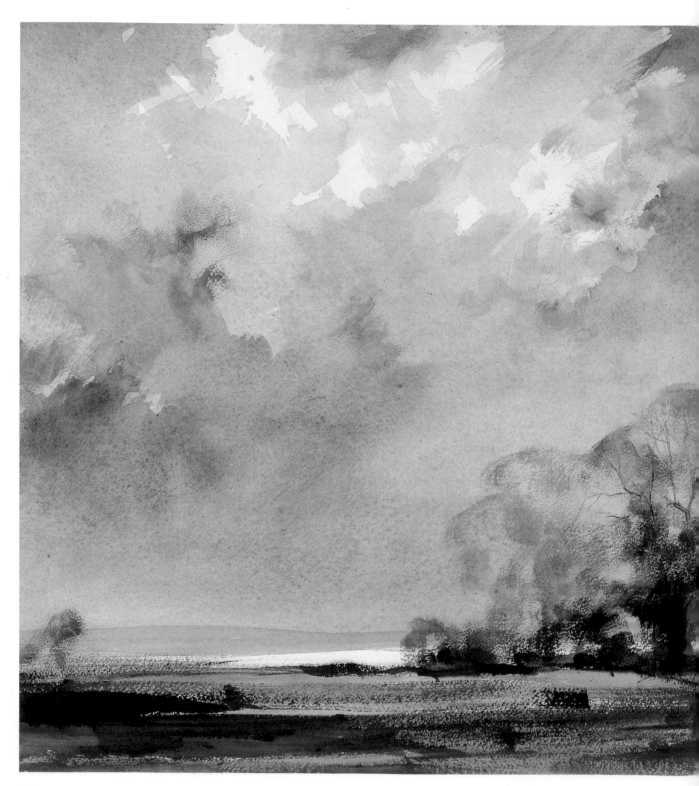

Rowland Hilder (1905–93)

Rowland Hilder has probably done more than any other artist in the last fifty years to reveal the English landscape to his fellow countrymen, in terms which they understand and respond to. His distinctive treatment of the English countryside has made his paintings the most easily recognised of our leading landscape artists. I have always admired his work and learned from it, too. As well as having all his books, I also have a hoard of his pictures gleaned from various publications over the years.

One of the techniques I learned from Hilder was the way in which he 'stage lit' his landscapes to produce dramatic effects. This was obviously a result of his early work as a black-and-white illustrator and brought a special quality to his work which is almost unique. Northern Kent has become known as 'Rowland Hilder country' because its hop fields and oast-houses have been portrayed for posterity in countless paintings of his over the years.

Looking at the distinctly English quality of Hilder's paintings it is difficult to believe that he was actually born in the USA. However, since his student days at Goldsmith College, he has been constantly in the forefront of landscape painting in England and was President of the Royal Institute of Painters in Watercolour for ten years.

The range of his work has been tremendous, from illustrating classical books such as *Moby Dick*, *Treasure Island* and *Precious Bane*, to the outstanding Shell advertising campaign of the 1930s, and the publications of Royles, with whom he worked for thirty years and which made him a household name.

It was as I was writing this short piece about Rowland Hilder that I heard of his death. As well as the sad personal loss to all those who knew him, his death will also be a tremendous loss to English art.

Edward Seago (1910–74)

Edward Seago has been the greatest single influence on my life and work. It was Seago's painting that inspired me to take up watercolour at a time of personal crisis. Incidentally, I have since written two books about him.

Dogged throughout his life by a strange heart

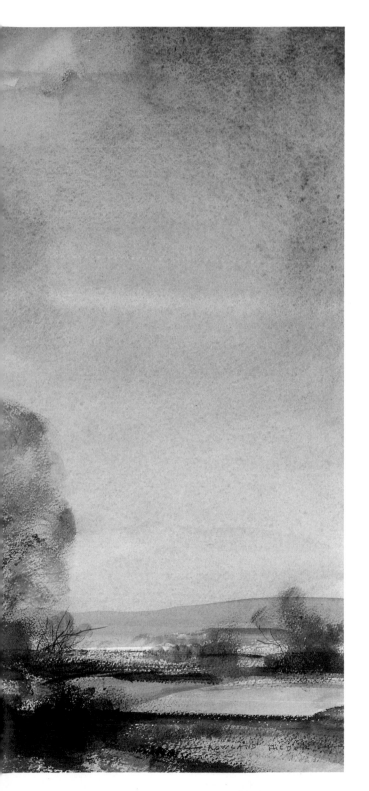

complaint, Seago had very little formal education. He spent most of his childhood painting, even during periods when he was confined to bed. His interest in art was discouraged by his parents and throughout his life he was forced to seek encouragement from others. His annual exhibitions in Bond Street galleries were unprecedented. Queues formed long before the doors opened and every exhibition was sold out within an hour. Seago was primarily an oil painter and took up watercolour later in life. His watercolours contained a directness and simplicity which was almost unequalled. His washes were left untouched and were an honest statement of his craftsmanship.

An artist's artist, Seago's work has had enormous influence on other painters throughout the world. Wherever I go, his work is spoken of with enormous respect and admiration

Edward Wesson (1910–83)

Edward Wesson was one of the best-loved painter/teachers of the twentieth century. This dynamic teacher of watercolour influenced many thousands and his gruff humour is legendary. He died almost ten years ago, working right up to the end. Wherever painters gather, their discussions still include 'dear old Ted'. In fact, as I write this, my own book about him, which contains over 120 of his paintings, is just arriving in the bookshops.

Wesson had strong opinions about his work and first and foremost was his dedication to 'purity' in watercolour. Asked which medium he preferred, his answer was always the same: 'When it comes off, there's nothing like a good watercolour.' A traditionalist, and proud of it, Wesson felt that watercolour had a unique quality, the key being the paper itself. He firmly believed that the process of painting should disturb the surface of the paper as little as possible; he felt that pushing the paint around and manipulating it destroys the magic.

Feeling as he did about the paper, inevitably Wesson always insisted that artists should make the best possible use of it by laying all the washes on it once only. This creates a wonderful luminosity not found in any other medium and if some of the paper is actually left untouched, in some circumstances it will give a natural sparkle which no amount of Chinese white would ever achieve.

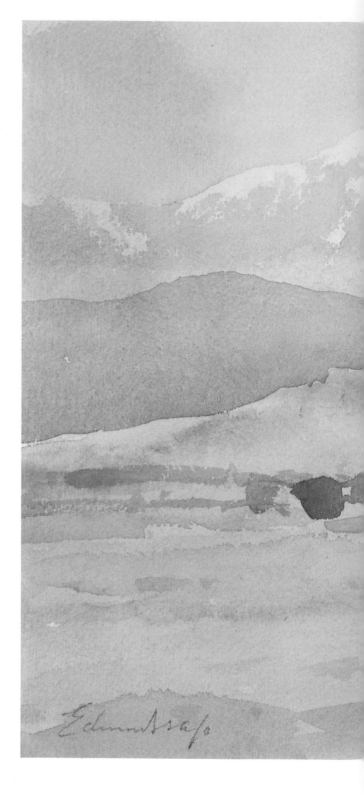

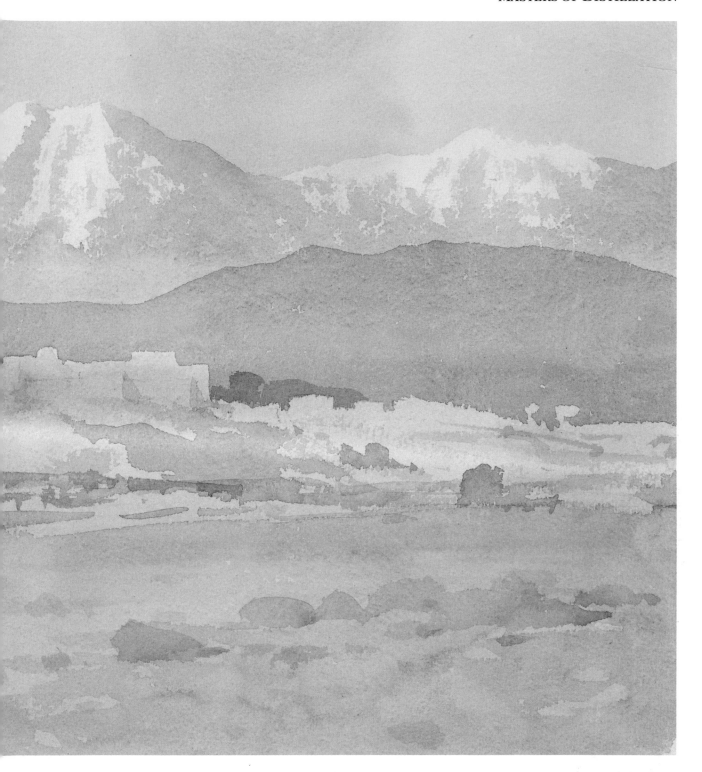

FOOTHILLS OF THE ATLAS by Edward Seago
If ever there was a single lesson in pure watercolour, then this is it.
The washes have been laid with economy and complete
transparency. The warmth of the colours creates an atmosphere of
shimmering heat. Even the foreground rocks have merely been
hinted at. Note the way in which the fort has been placed just off-
centre, but the whole painting is perfectly balanced.

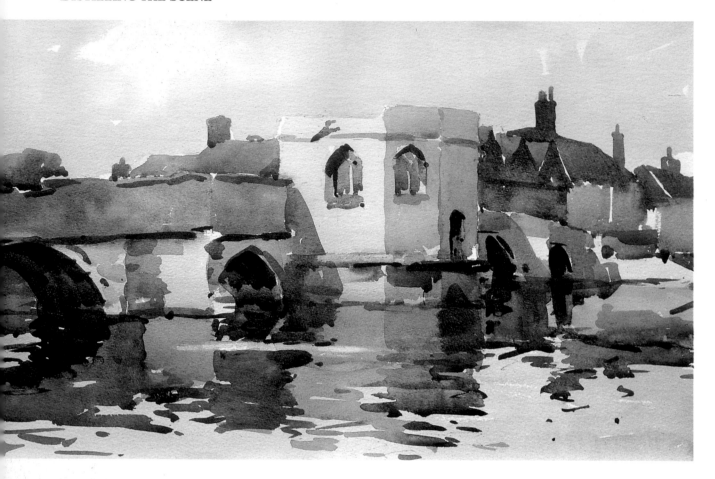

One of the ways in which Wesson achieved his loose and distinctive style was the use of his large French polisher's mop rather than the more conventional sables.

Like all the artists mentioned in this chapter, a main feature of Wesson's works was his remarkable economy of stroke and the simplicity of his paintings, gained by meticulous observation of his subjects and strong self-discipline.

John Yardley (born 1933)

John Yardley is a relative newcomer to the art world, having spent most of his working life in a bank. This, of course, offered security but frustrated his artistic abilities. Completely untrained in art, he worked for thirty years at nights and weekends to perfect his painting. Finally, however, in 1986 he was able to take early retirement from the bank and pursue his art full time. Since then his rise has been meteoric and he can hardly keep up with the demand his work has created. He also travels widely, collecting material for his varied subjects.

Yardley was featured in my book *Watercolour Impressionists* and later I produced another illustrated book devoted entirely to his work. I admire enormously his ability to simplify a scene to its basic pattern, as well as his way of painting which the layman can understand and appreciate.

In recent years, Yardley's subject matter has widened even more and he leaps from interiors to flower paintings to busy street scenes. He discovered an ability to describe a moving figure with an astonishing ease and conviction, using the minimum of strokes. With no more than a 'smudge' of paint, he gives a viewer a fleeting impression of twenty different people bustling about their business in a city street – the quick, the slow, the ponderous and the slight all displaying their own particular movements. After careful observation, his brush moves with lightning speed when he finally makes his considered stroke.

I feel fortunate to possess twelve of Yardley's paintings and I know that his future is assured as one of our great watercolourists.

ST IVES, HUNTINGDON by Edward Wesson

I love the subtlety of the warm and cool greys and browns in this picture. When I saw this painting in an annual R.I. exhibition, I rushed towards it, only to find that it already had a red sticker on it! I feel that this is a fine example of Wesson's transparent watercolour.

CHARLES BRIDGE, PRAGUE by John Yardley

In his early days, John Yardley was much influenced by the work of Ted Wesson. However, once he began to increase the importance of figures in his painting, his work began to have a unique feeling which is truly John's own. I know of no one who can match him in the free interpretation of people. This example shows street musicians performing in the Czechoslovakian sunshine. I always admire the contrast and counterchange in John's work which is used here to great advantage.

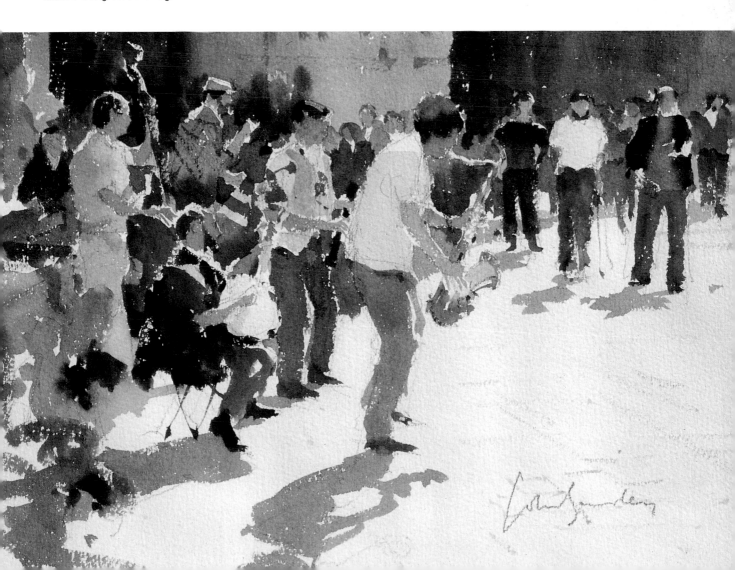

2

MATERIALS

It has been said that amateur painters are afraid of boldness and that professionals are afraid of timidity. Although I regard myself as an Impressionist type of water-colourist, I still have a mental battle against 'tightness' caused by a fear of taking risks and by trying to keep to safe ground. Sometimes I win this battle, but more often I lose. It's perhaps understandable that many of the winners are done on odd scraps of paper where I've already failed on one side and have therefore already lost the money I've paid for the paper in the first place, thus removing one of the inhibitions! The point I'm making is that there is a lot of personal psychology in watercolour painting. I feel that the materials we use can have a marked effect on our mental attitude and subsequent results, particularly as we're trying to move on in our painting, concentrating on distillation and improved composition.

Being something of a rebel, I soon abandoned the more conventional materials – the tiny sable brushes and little square pans of colour, the small palettes and expensive hand-made paper. They all seemed too restricting and inhibited my attempts at freedom. I decided therefore to produce my own set of materials to help me loosen up.

Paints

First the colours. Instead of the score of colours normally used, I restricted myself to seven. Instead of buying expensive 'Artist Quality' pans or little tubes, I bought large 21mm tubes of Cotman watercolour made by Winsor and Newton. The very size seems to encourage you to squeeze out generous quantities rather than being stingy with the more expensive tubes, thus removing another psychological barrier. My palette consists of: raw sienna; burnt umber; ultramarine; Payne's grey; light red; alizarin crimson; and lemon yellow hue.

Brushes

I've restricted my brushes to three: my big hake, which I use for about three-quarters of my painting; the 1in (2.5cm) flat with the bristles made from man-made fibre, which I use mainly for buildings, boats and other sharp objects; and the No 3 rigger, a very flexible brush which I use for figures, branches and grass.

Palette

My palette, too, is larger than life, being an ordinary white plastic tray. I don't like the palettes with little square partitions because they harbour so much dried-up paint. Yesterday's paint is too unsympathetic – I like fresh mobile paint for each painting. This may horrify more conventional painters who try to keep their bits of paint going for weeks – wearing out their brushes in the process!

Water-pot

When I'm working outside, I use a collapsible water-pot which hangs from a metal easel. You will also need a good supply of rags whether you're inside or out, which are essential to remove the excess water which causes so much chaos for first-time users of the hake.

Paper

I prefer Bockingford 140lb, in pads. I find the more expensive, continental hand-made papers rather inhibiting because of their high cost. I also scorn convention by never stretching my paper although I know thousands of people do. I find that a spring clip on the loose edge of my pad is perfectly adequate to stop the paper curling.

So you can see, as well as attempting to 'distil' in my painting, I've also done so with my materials.

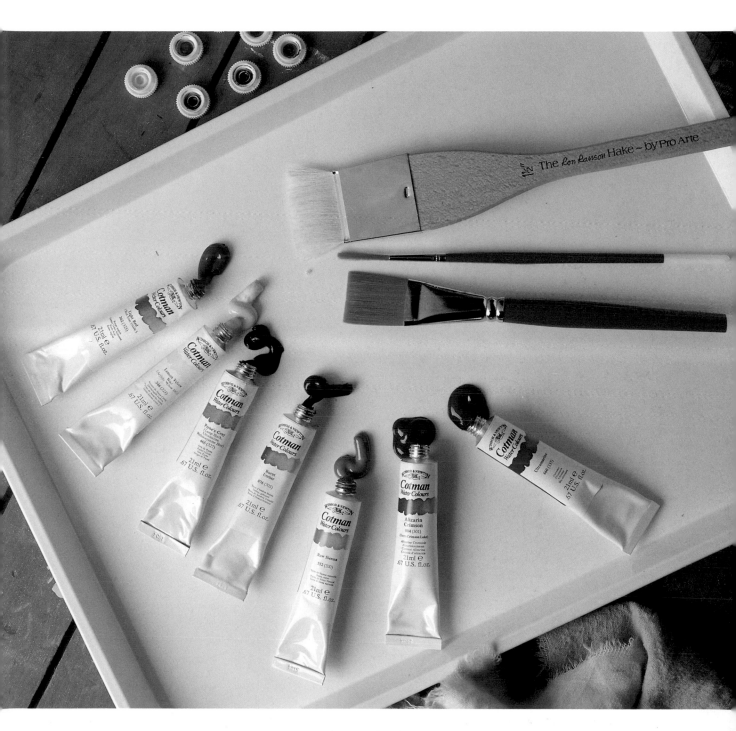

The photograph above shows the basic materials which I use in my own work and teaching. They've been deliberately reduced for simplicity's sake. The mixtures made by the seven colours are soon memorised and the use and purpose of the three brushes quickly learned.

Here you can see part of the interior of my new, purpose-built studio. The balcony has a beautiful view of the trees and stream below. Although it may all look rather swish, in fact I've had most of the equipment for years and even then it was second-hand! I use it not only for my own work but also for the painting courses I run here at home near Chepstow.

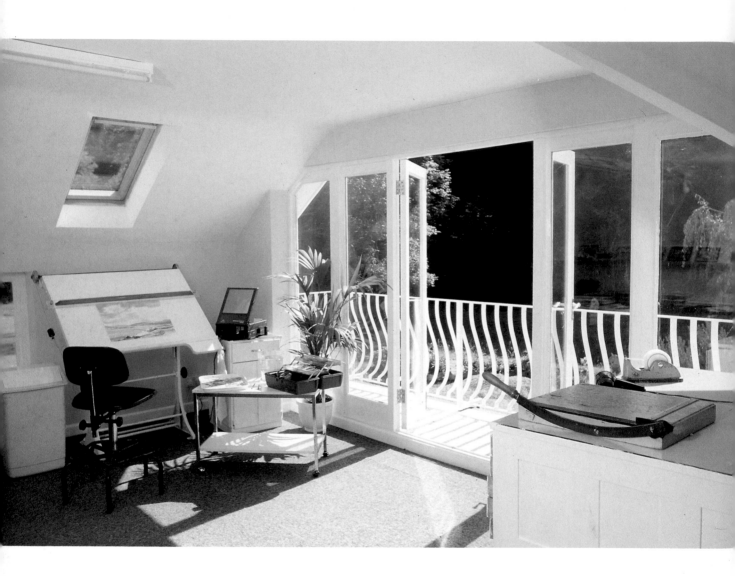

The Studio

Regarding my studio, I've been very lucky. I've just bought a charming cottage in a beautiful garden complete with stream and mature woodland. This has given me the opportunity to have a studio built to my own design. I spend much of my day here, either teaching students, painting or producing my books. The studio is on the first floor and has a balcony which is super to paint from. Carpeted with Heuga carpet tiles which are virtually indestructible and impervious to splashed paint, it really is ideal for all my activities. It contains a full-size table-tennis table which, when covered, provides comfortable working space for six students, and another six can be accommodated in other parts of the studio. I've used kitchen work-tops with curtains to hide the inevitable debris underneath, and there are also two large plan chests, one of which supports my sophisticated duplicator, essential when I'm writing my books. My easel is an old disused drafting board which I picked up very cheaply, painted white and covered with white laminate.

You'll notice in the picture a transparency viewer which blows up transparencies to about

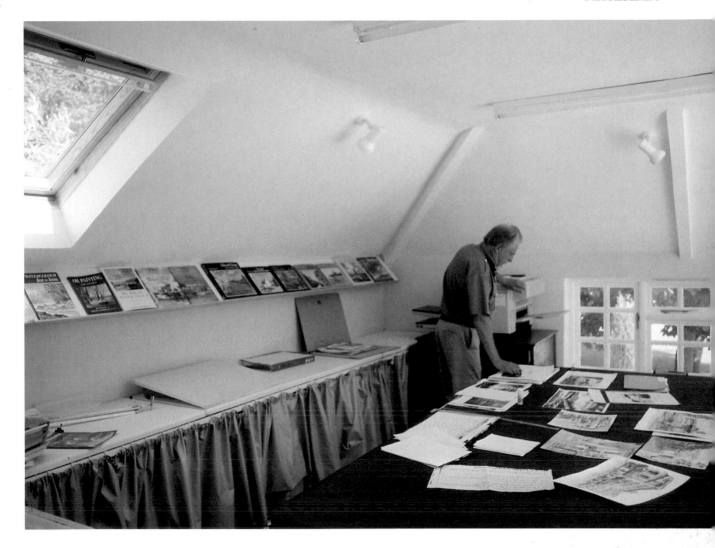

Another corner of the studio. This time I'm working on a covered table-tennis table which is ideal when I'm producing my books – there's plenty of room to spread out. The 14 finished books are displayed on the shelf behind me.

10in (25cm). This can be used in daylight and, being fan-cooled, can be left on for long periods without overheating. You may also have noticed the rack which contains my finished books which are well thumbed by my students! All this may seem rather luxurious, but please bear in mind that I've only achieved it after many years of making do with kitchen tables and the like.

I do hope that the pictures in this chapter will give you a few ideas and that the distilled materials may help to change your outlook and simplify your style.

TRAINING THE MIND AND EYE

Select and Reject

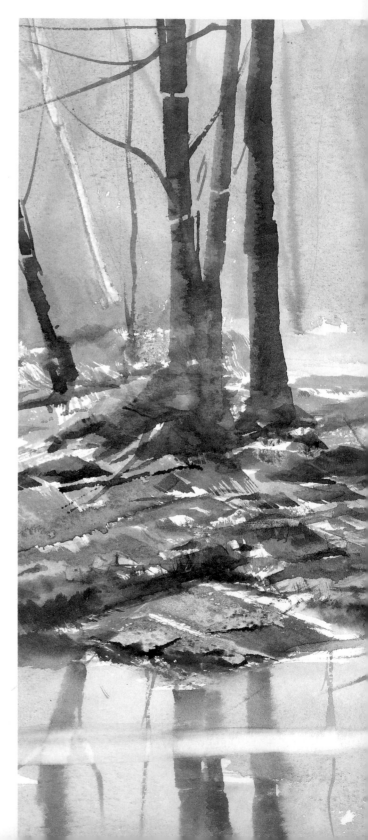

Once you've mastered the basics of your craft and learned to portray everything in front of you as accurately as possible, it's time to move on. Now you must learn to become more critical and selective of nature's design. It will take time to train your mind and eye to this new task, but it must be done if you are to progress from being just an amateur picture-maker. As the famous watercolour teacher, Ed Whitney, once said: 'I make my bow to nature, then do as I damn well please.'

As an artist, you can't hope to transcribe all that's in front of you, even if you wanted to. The scene before you is three-dimensional and is bathed in beautiful light, while your paper can only have two dimensions and you only have paint to help you. Therefore, of necessity you have to translate the beauty of the scene rather than the actual fact. You must reject absolutely everything that doesn't convey your own feelings about the scene and emphasise all those elements that do. The decision of what to reject needs as much skill and sensitivity as the portrayal of the essentials. As a teacher I find this stage one of the most difficult for the intermediate student, and I'm constantly being asked, 'What do I leave out?' Once you see the work of a truly skilled professional, however, the process of rejection and the reasoning behind it become self-evident.

The process of rejection begins with finding the subject and gradually homing in on it and intensifying it. At first, you may find that a small viewfinder is a great help in eliminating extraneous material. This can be made simply by cutting out a rectangle from a postcard. Initially you don't even need your paints. The whole object is to improve your skill in selecting your basic subject.

TRAINING THE MIND AND EYE

In this picture of a misty woodland glade, the whole of the background was portrayed using wet-into-wet cool greens, resulting in the rigger work being blurred and thus adding to the atmosphere. As I moved forwards, I warmed up the greens and as the background dried, I was able to indicate the foreground trees more sharply. A variety of strokes were used to obtain the foreground textures, as well as the inevitable fingernail and a credit card for the top of the rocks. Finally, the water was painted using a preliminary wash of pale grey-blue and while this was still damp, the reflections of the trees were added using stronger paint.

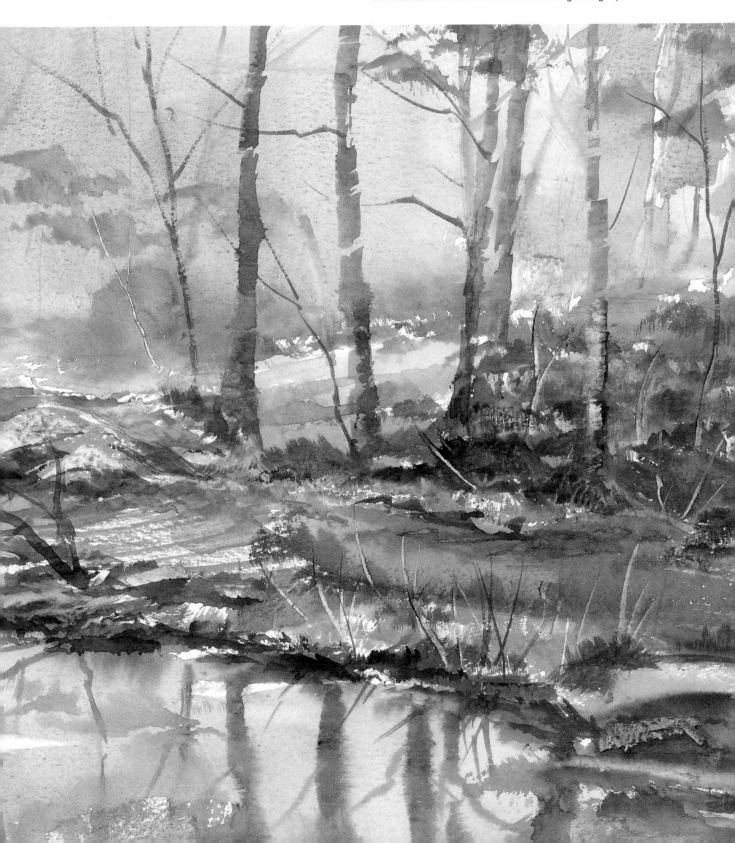

Planning

The next stage is to screw up your eyes to a narrow slit which will immediately cut out petty detail and enable you to see your subject in simpler terms (you see too much with your eyes wide open). If you think that you're now going to sit down and paint the picture, you're wrong! You haven't designed it yet, and you've no hope of designing it as you paint. Trying to cope with the difficulties of tone and colour mixing is quite enough. After all, you wouldn't just start to build a house, you would first sit down with an architect, work out your requirements and perfect the design. You might be the best bricklayer in the world but you still wouldn't have a viable house if you hadn't first completed the groundwork. Similarly, however good a technician you are, without careful planning your work will be bitty and confusing.

Planning is a huge barrier which daunts most amateur artists. They would rather paint their picture by trial and error than 'waste time and paper' in preparation. This lack of planning, however, is what keeps them amateurs and prevents them from attaining a professional standard of work. It's important, therefore, that if you want to produce professional work, you must be determined to put this particular barrier behind you and do some careful preparation.

I hope that the illustrations on this spread will give you some idea of the approach. I find that working quickly, possibly even setting a time limit, is important. I've often thought of buying a cook's timer to put in front of me while I paint! On the final day of my course I make my students do what they call a 'half-hour quickie'! I ring the bell on the side of the house and off they go. At the end of thirty minutes the bell rings again and they must stop – even if they haven't finished. There's an atmosphere of silent panic as the brushes fly. Believe me, the best paintings of the whole course are often produced during this period.

Right
This shows how few elements are needed to produce quite an attractive picture. A low horizon, a tree, and an interesting sky are all that are needed. There is a variety of techniques here – wet into wet for the sky, a simple flat wash for the distant hill, and good fast horizontal strokes for the foreground. Remember always, never fuss your foreground.

Below
Here we have a simple scene in Greenwich, Connecticut. The picture divides neatly into three planes. The background village, painted very flat and cool, the middle ground in warmer greens, and the foreground in rich contrasting colours and tones to bring it forward. This is drawn in vignette form. Notice the use of the white paper.

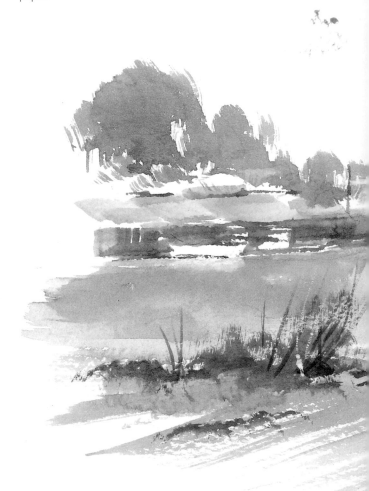

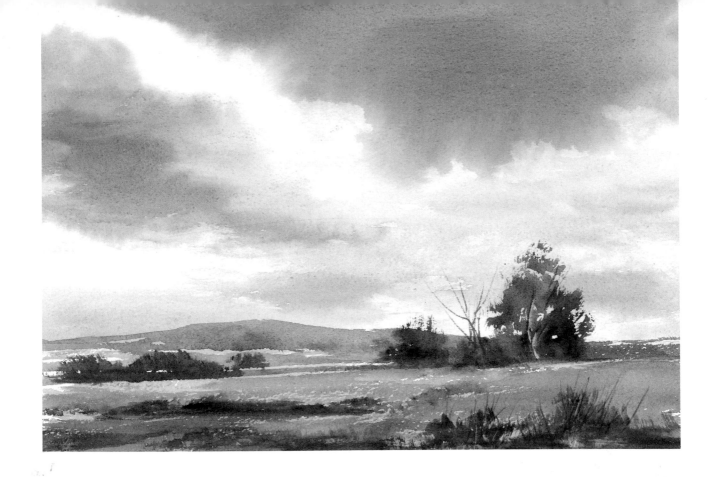

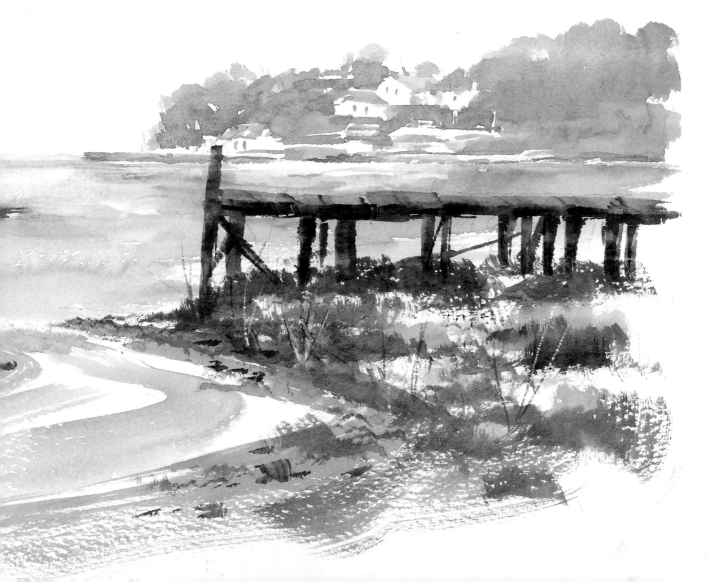

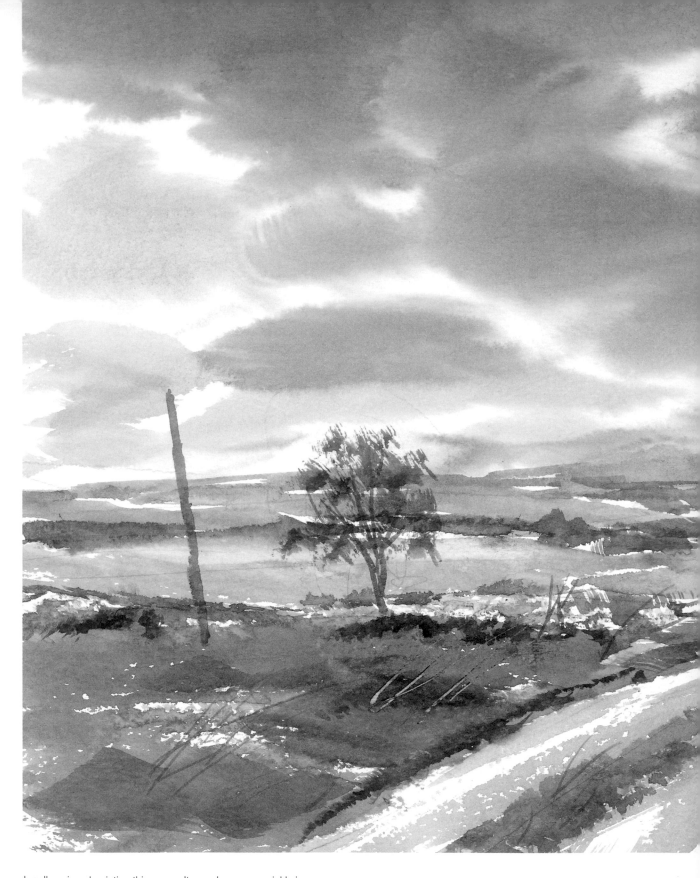

I really enjoyed painting this scene. It was done very quickly in a howling gale on Salisbury Plain, near where I teach in Dinton. Clouds were of course the main feature, exciting forms of cumulus which cried out to be painted rapidly and boldly. I've also tried to convey the wind by the directional strokes of the grasses. It would have been even more convincing if I'd made the figure lean into the wind and hold on to his hat!

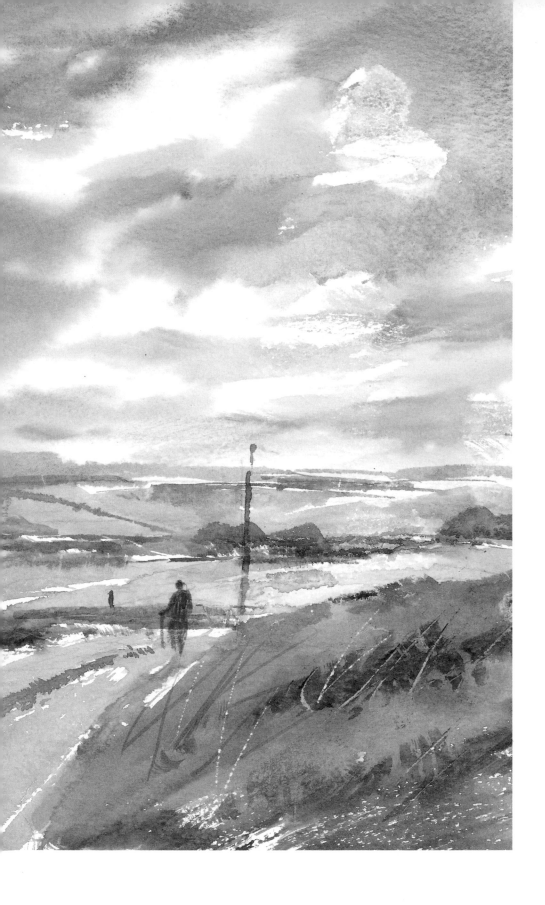

CREATING YOUR OWN STYLE

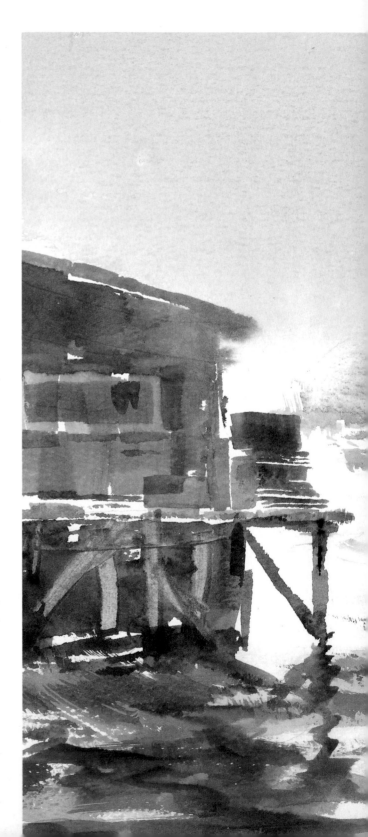

Most watercolour books, including my own, concentrate on the basic techniques of applying watercolour – wet-into-wet, dry brush, etc. To become really fluent and confident you'll have to work at this for a year or two to learn your craft. Those people who say that the ability to paint is a gift, are wrong – it's mostly a case of sheer hard work.

Most of us have a favourite artist we would like to emulate, and are influenced by his or her style. The time comes, however, when you have to leave your mentor behind and put your own unmistakable mark on your painting. I freely admit that my personal hero was Edward Seago, whose work inspired me to take up watercolour at the age of 50, a process which has changed my whole life. Such was my admiration for the man, that subsequently I have produced two books about him. His personal style is recognisable from the other side of a street.

Another painter for whom I have enormous respect is Edward Wesson, a charismatic artist and teacher whose work has influenced thousands of would-be watercolourists. To quote from my book about him:

> He was often asked whether it was in order to copy another artist's work. He always said 'Why on earth not?!' He had no hesitation at all, on a wet day, in offering sketches of his own for copying by the students. He felt that if they, as individuals, had anything at all to say, it wouldn't be long before they were saying it in their own language.

The most important part of the quote is the last sentence, in which he is saying that you must learn to create your own style, which should be as unique as your own signature; you should try to get away from being an efficient but anonymous watercolourist. This progression is

This was a demonstration I did in a thick fog in the little village of Port Clyde in Maine, where I teach every year. I've tried to give a rough impression of the place in this atmosphere using very few strokes and painting as rapidly as possible. As you can see, much of it is wet into wet to convey the blurred outline which the fog produced. I find that demonstrating concentrates the mind and adds to the excitement.

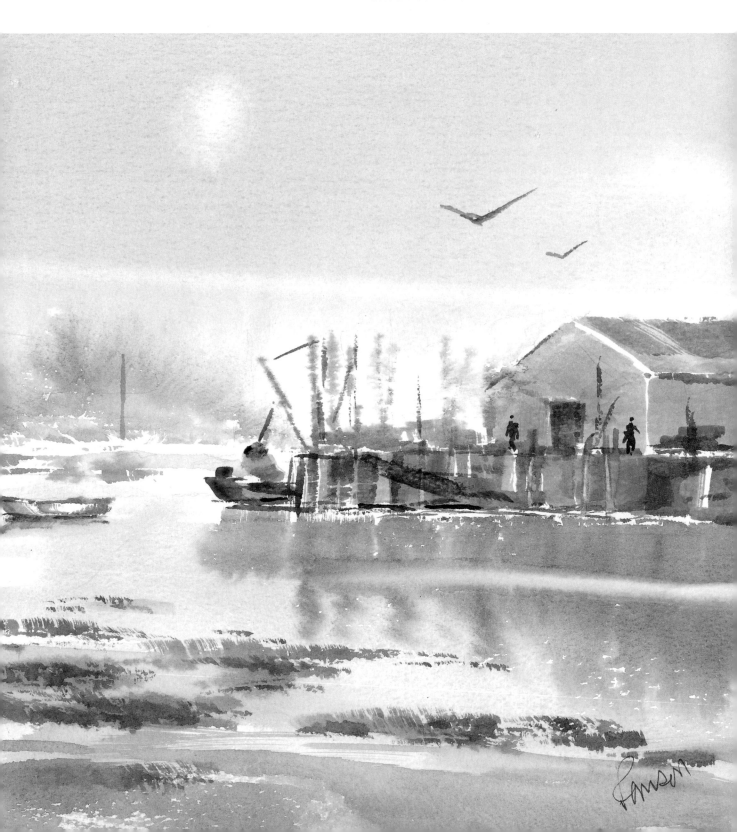

a very important point in your painting career. Incidentally, you'll find that the selection committees of such bodies as the RI and the AWS, when looking for new members, are searching for just this elusive quality.

Having accepted the idea of creating your own style, how do you go about acquiring this quality? First of all, don't be in too much of a hurry. You can't go out and choose a style, as you would a dress or a jacket. Your own style will gradually evolve as you work and develop your own mental attitude as well as your technique. Learn to avoid the pitfalls. For instance, beware of flashy techniques. You won't suddenly become unique because you've learned how to use salt, candle-wax and tissue-paper, or by stamping your washes with cellophane.

Your eventual style must be flexible enough to encompass all the different moods and subject matter that you'll encounter in different parts of the world. It's too easy to become a one-picture artist, churning out many variations of the same themes just because they always sell. All you'll be doing is creating a strait-jacket for yourself which will stifle your style, your creativity and enthusiasm.

Expressing Emotion

One of your most valuable assets that enables you to express your individuality is your own emotion. After all, one of the hallmarks of any great artist is the ability to feel deeply about the content of his or her work. One of the ways in which you can harness your emotions is to expose yourself to those things in your environment which will stimulate your creative thoughts – for example, the dramatic lighting of early morning or evening, a mist on the river, or the brilliant light of midday. All these provoke emotional responses, and this excitement will become evident in your work.

Every now and again during my painting year, I find a subject which provokes such a response in me that the hairs on the back of my neck stand up and I know that this will be a good painting. These few paintings are far superior to the rest of my work, and I only wish that it would happen more often.

Try to work occasionally at a more fevered pace. Move rapidly over the surface and treat forms more simply, attempting to instil the spirit of the subject in your painting. This, of

This quiet morning scene was painted on the River Wye near my home. I love attempting to create the subtle colours of the area where the mists rise gently from the river. I painted the top hill sharply and then watered the paint down to achieve the misty effect. Watercolour really lends itself to this type of peaceful scene.

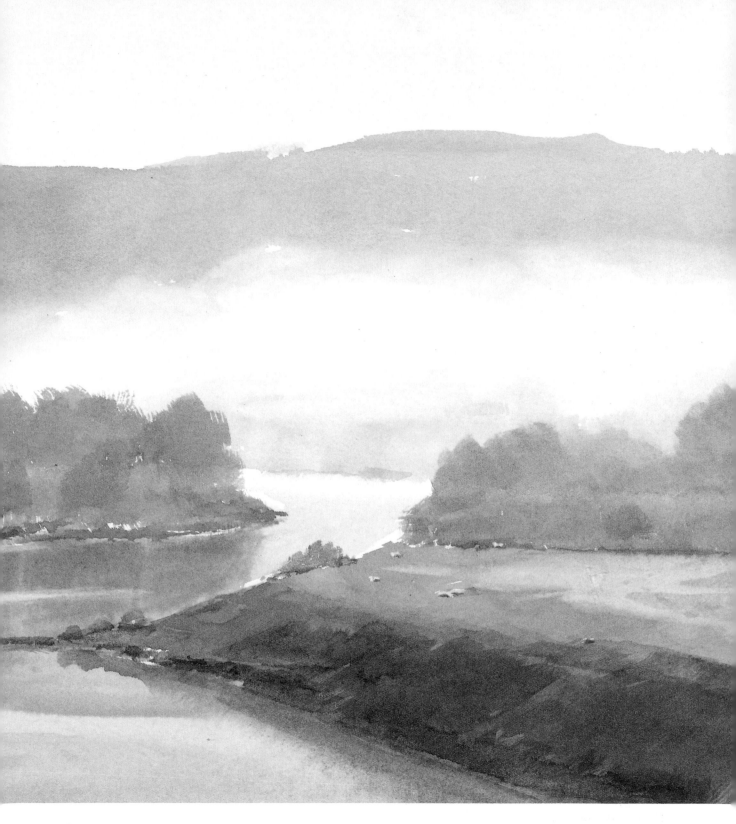

Overleaf
Here is another picture of Port Clyde, though contrasting sharply with that on page 28. This time it was a clear morning with just wisps of cirrus clouds. I've tried to give a strong sense of depth by painting the background village a pale shade of blue whilst warming the colours as they came forward. The foreground beach was pebbly, so I've indicated this with fast, dry brush strokes.

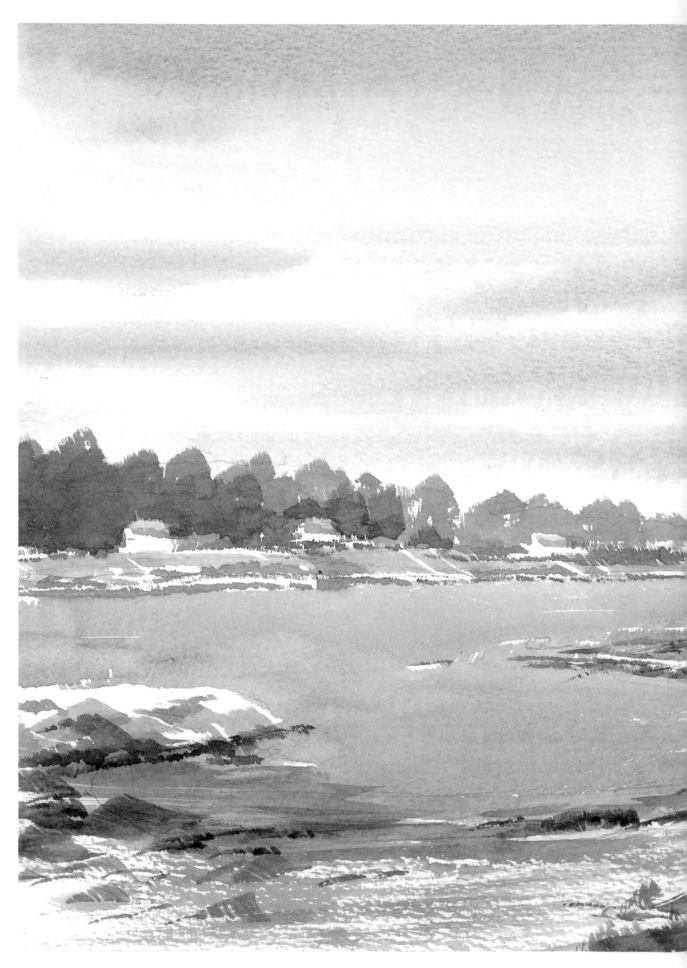

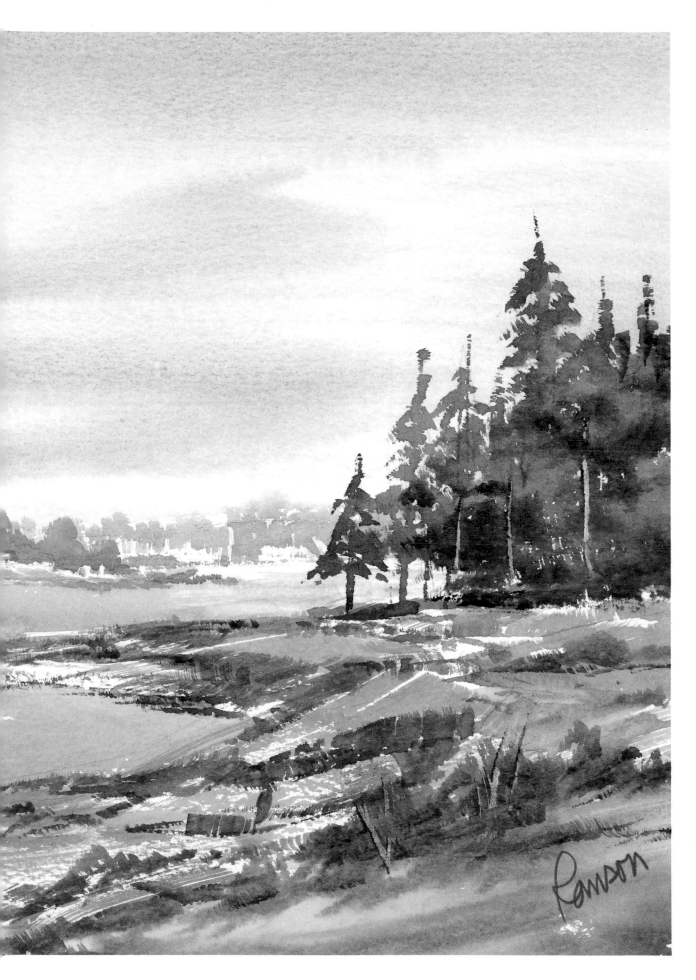

course, involves taking risks and your first efforts may seem out of control. However, as you become more experienced in this approach, you will soon regain control, yet your work will ooze vitality and excitement.

A famous quotation of Albert Einstein is very relevant here: 'Imagination is more important than knowledge.' Try to get out of your comfort zone and be willing to explore and use your imagination to look for the more unusual aspects of your subjects. Be really daring, give a free rein to your use of fantasy rather than being too down-to-earth and stolid.

The style you produce is the result of your own particular way of feeling and reacting. After all, no two people ever react in exactly the same way in any given situation. To be able to make visual statements in your own unique way is the most satisfying aspect of painting. The more you paint with this frame of mind, the easier it will become to create your own unique imagery. Like your handwriting, the way you express yourself in paint will be uniquely and recognisably your own.

Of course, this way of expressing yourself is risky, but failure can be positive in as much as it can be part of the learning process. Let's face it, watercolour is a risky medium, but once this risk is accepted, it too can be used to develop your own style. If I may quote from my first book: 'It's better to have a glorious failure than a weak miserable one.' Even if you only get four good paintings out of ten, this willingness to take a chance is what will produce the real winner.

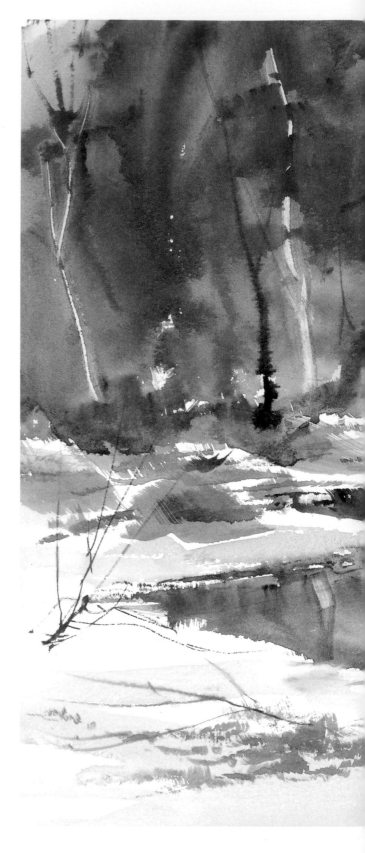

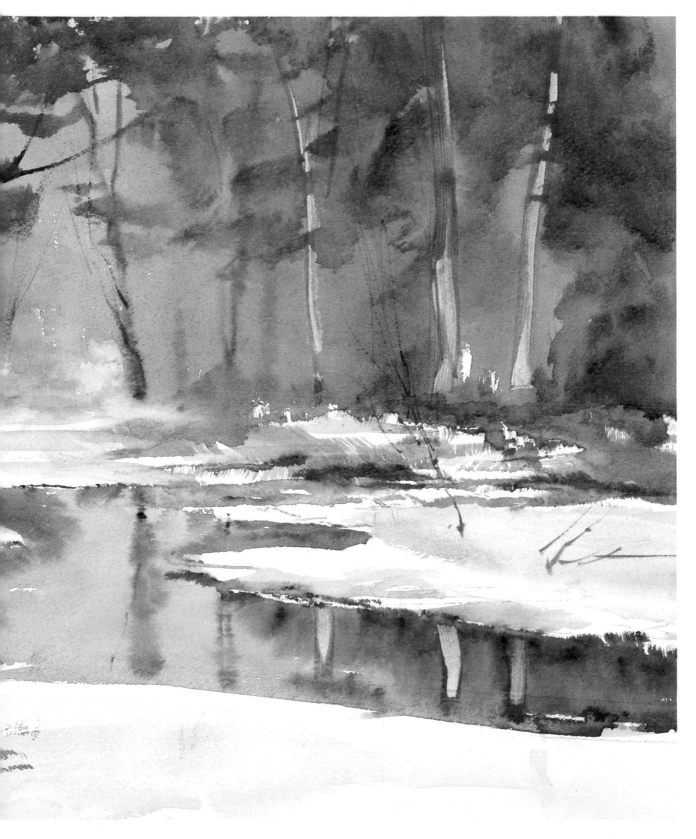

In this snow scene, I really let myself go. I've tried to keep the background woods as fresh, rich and loose as I could, dropping almost neat colour into the wet, and using the other end of my hake along with my fingernails to get the white trees while the paint was still damp. To achieve this freedom you have to be in the right mood and not be too worried as to whether or not you're going to spoil the picture. Being too careful would simply have ruined it.

DESIGN IN WATERCOLOUR

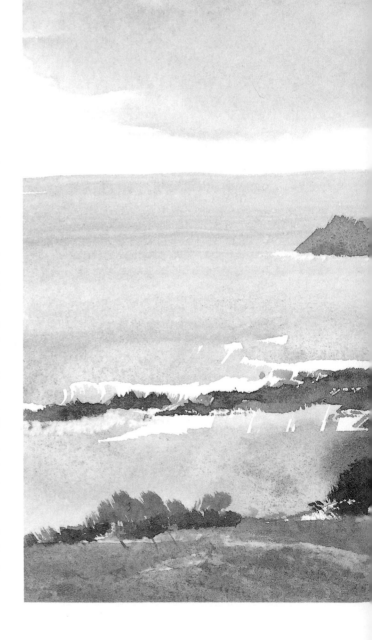

Many watercolour books explain the laying on of washes and the various techniques of applying paint, but skip over the actual design of the picture itself. This is strange when you consider that it is design that wins awards and gets paintings into national exhibitions and is what is lacking in rejected paintings. While the ability to design may not be something that artists are born with, it is, however, something which can be learned. Design has definite rules which, once absorbed and applied, will take your paintings into another league. Your ignorance or knowledge of these rules will show in every painting you do, regardless of subject matter.

The principles of design apply to all the arts, whether it is drama, photography, music or industrial design. However, in 1951 an American called Maitland Graves wrote a book called *The Art of Color and Design* in which he applied these principles to visual design generally. At about the time he wrote the book, Graves was teaching at the Pratt Institute in New York, a famous and prestigious college of art. Here he met and influenced another American artist, Ed Whitney, who was to become the most famous teacher of watercolour in the USA. He it was who adapted the principles of design to the process of painting watercolour. A man of enormous vitality and personality, he discussed his ideas nationwide. Students of all abilities flocked to his workshops and, by applying these principles, began to win an enormous proportion of American national watercolour awards. I was so impressed by this giant of a man, who went on teaching well into his nineties, that I've recently written a book about him and his methods and ideas.

This is a cliff top scene on the island of Monhegan painted as quickly and simply as possible. The large tree on the right has been balanced by the small dark trees on the left. Notice how the colour and texture in the foreground have been varied to avoid monotony.

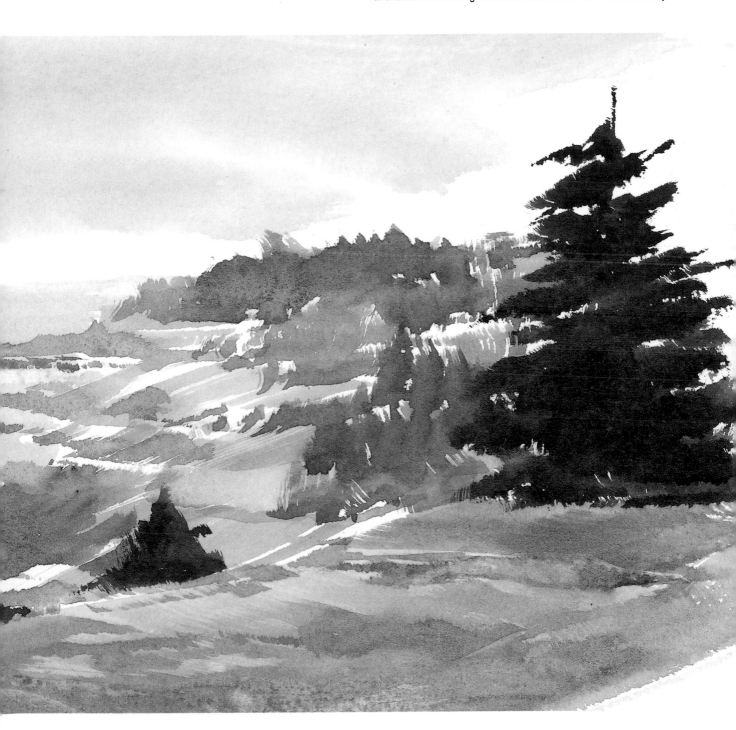

Seven Component Parts

Before you can apply the principles of design to a watercolour, you must first break down the painting into its component parts. There are seven of these in any painting and they are the raw material from which a design is built. They are: shape, size, line, direction, colour, value, texture.

Shape A shape is anything that has height and width and it can be placed in three categories: curved, angular or rectangular. All three can appear in a painting but one must be dominant – ie, one shape must be larger, appear more often or both.

Size Shapes are of various sizes to one another, larger, smaller or the same size.

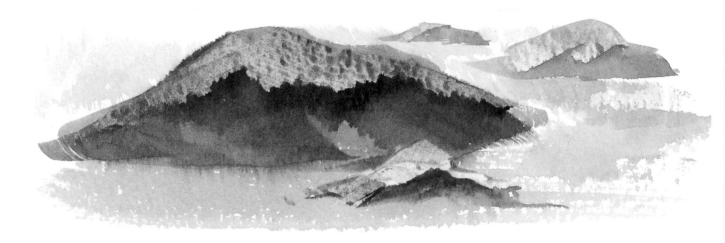

Line Lines in a painting are either straight or curved and although both can be in any one painting, again, one must be dominant.

Direction In a painting, one direction must be dominant, whether it is horizontal, vertical or oblique. Where the horizontal is dominant, the majority of the lines and shapes will also be horizontal, whereas the vertical shapes will play only a minor part. If the vertical is dominant, then the opposite occurs and you could actually start the process by using the paper vertically. When the oblique is dominant, then the lines and shapes will be sloping.

Colour You need to learn to use colour properly to get atmosphere and excitement into your painting. I will talk more about this in Chapter 12.

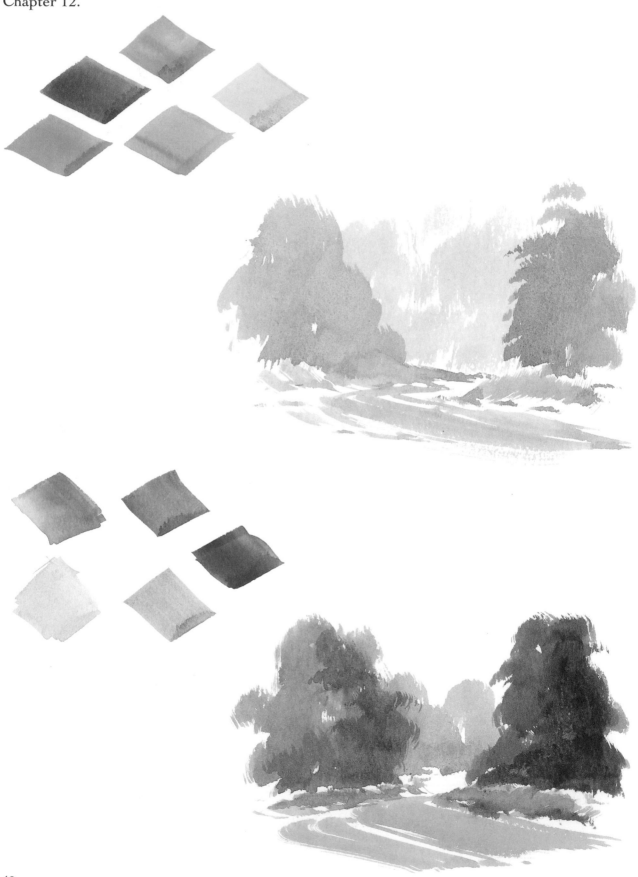

Value Value is the lightness or darkness of any colour and its use in any design is of paramount importance.

Texture Texture is the surface quality of objects, and in painting, this can be divided into three simple categories: soft, rough and smooth.

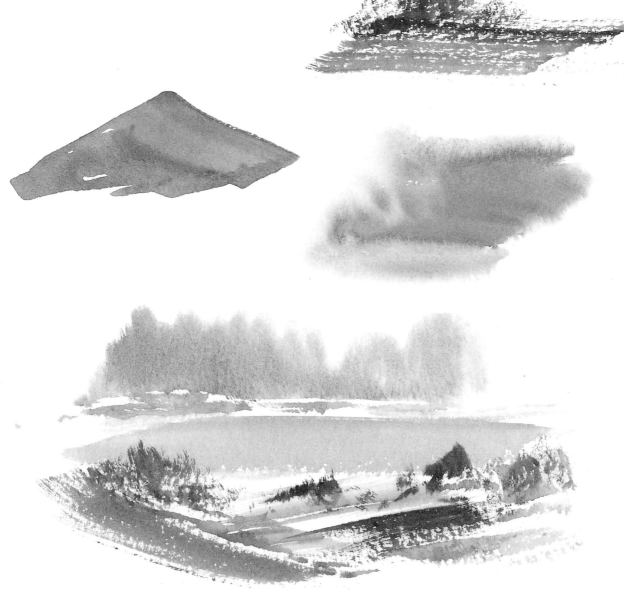

Eight Principles of Design

The eight most important principles of design are: balance, harmony, gradation, contrast, variation, alternation, dominance, unity.

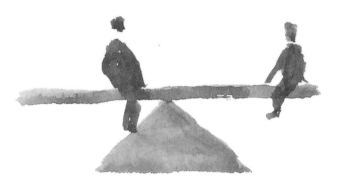

Balance The easiest illustration of balance is probably a see-saw. If all the larger shapes are on one side of a picture, it will appear out of balance. If, however, you move them nearer to the centre of the picture, they can be balanced by moving smaller shapes away from the centre. This is what is known as informal balance. Formal balance is when you have two shapes of equal size on either side of a picture, but this is usually less interesting. You'll see this in the illustrations.

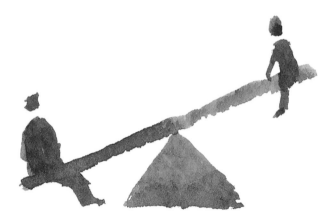

Harmony Harmony simply describes elements which are similar to each other. Harmonious colours are those which are adjacent on the colour wheel such as red and orange. A circle is harmonious to an oval, while harmonious shapes are those which are close together in size.

Gradation This is a gradual change from one thing to another. For instance, in colour, it's a gradual change from cool to warm colour or vice versa and in value it's a gradual change from dark to light or light to dark. The technique is used to create interest in an otherwise flat, boring area.

Contrast Contrast is best described as an abrupt change from one thing to another, be it from light to dark in tone or from warm to cool in colour.

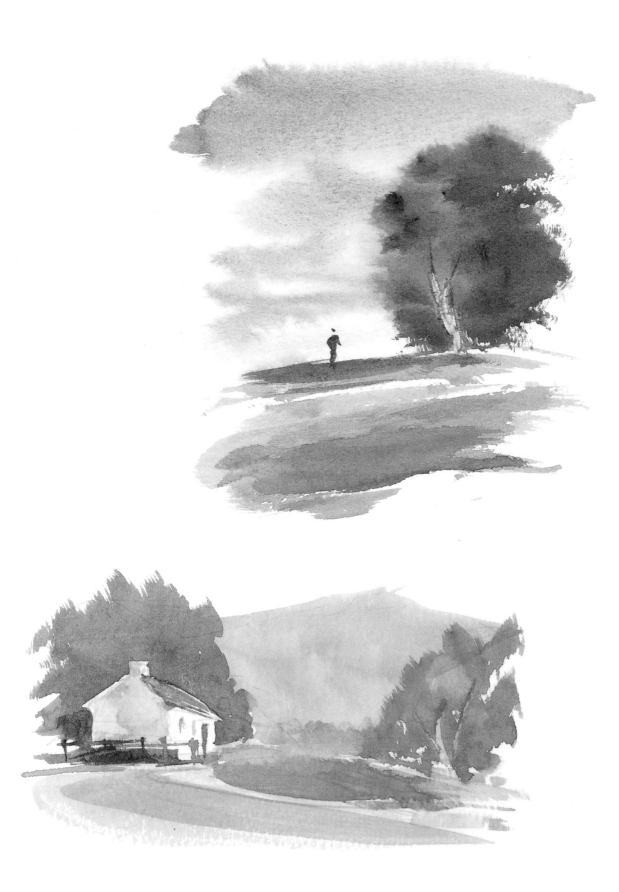

Variation and alternation These are two ways of repeating yourself in a painting, be it size, shape or colour, to avoid a monotonous effect. To repeat an element with variation can be very effective as it provides visual entertainment – part of the artist's job. You should never have a large area of painting without variation, and this can be achieved by making it lighter, darker, another colour, or a combination of both.

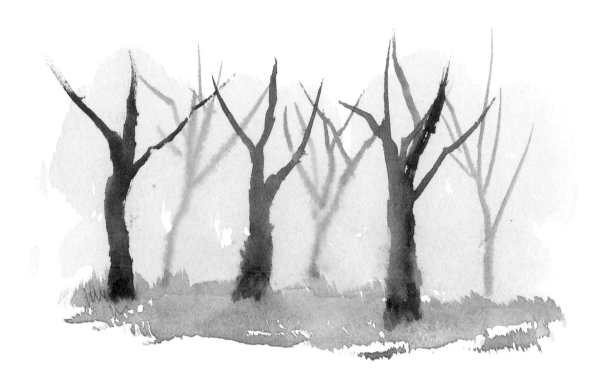

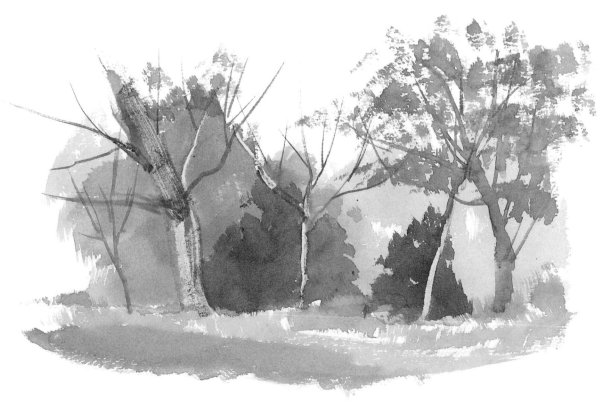

Dominance Probably the most important principle of design is dominance. In any painting, one unit must be more important than the rest. This importance can be achieved by making the unit larger than everything else, by providing more value contrast around it, by making it the brightest colour or a combination of these. If there are two trees, then one must be larger than the other. One cloud in a sky must be larger than the rest or one mountain must be larger than the others. This is how you will achieve dominance in your painting.

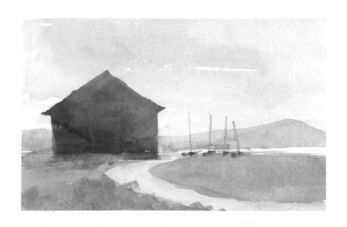

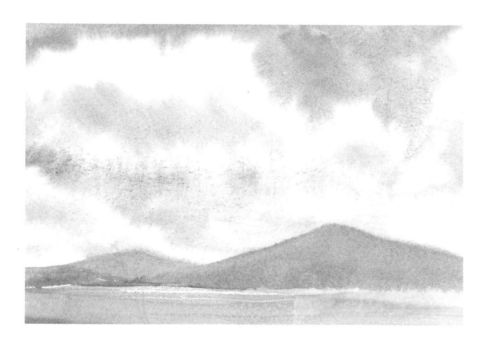

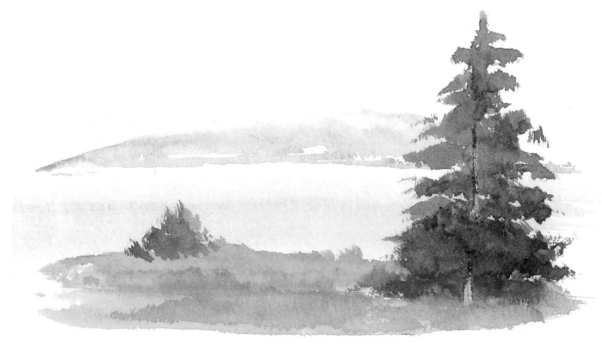

Unity To be worthwhile, a painting must be a complete unit and lock together as such rather than being merely a collection of several bits. If any of the elements appears in one section of the painting, it should be echoed in another part. In other words, it should be related – for example, a large tree could be echoed by a smaller tree, or a large patch of colour could be echoed by a smaller patch in another part of the painting. These are best done in an oblique way. You can also do this with shapes by echoing your tree in a cloud shape. Never make these echoes the same size – one must always be smaller than the other.

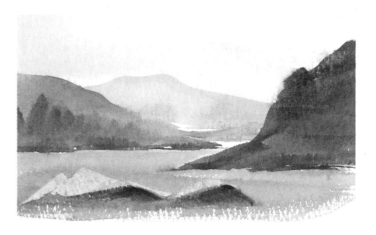

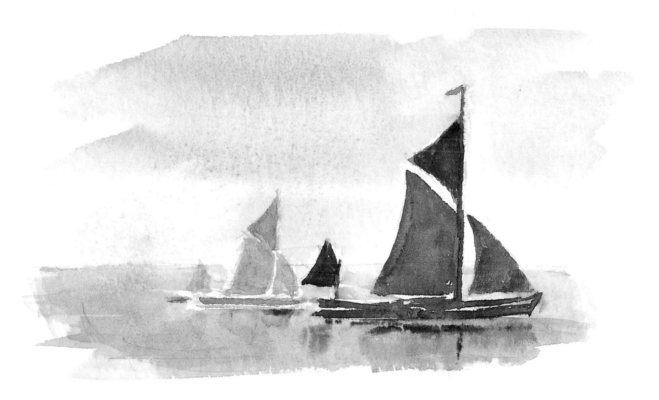

All this might seem a lot to take in at first glance, which is why many artists tend to avoid the techniques altogether. Once learned and used instinctively in your paintings, however, you'll find that your work will be vastly improved. A good idea is to create a basic check list, such as the one below, which can be used to judge your painting.

1 **Dominance** of, say, colour, shape, texture, line.
2 **Variation**, particularly of large areas.
3 **Unity**, perhaps by echoing.
4 **Entertainment**, by repeating with variation.
5 **Contrast**, of dark against light and vice versa.
6 **Balance**, remember the see-saw.
7 **Main object** of interest.

It's not necessary or even practical to apply all the principles to each part of your painting. For example, you could probably have a well-designed picture if you applied the principle of dominance to, say, three of the parts of the painting – say, direction, shape and texture. This would also provide your painting with unity.

TONAL SKETCHES

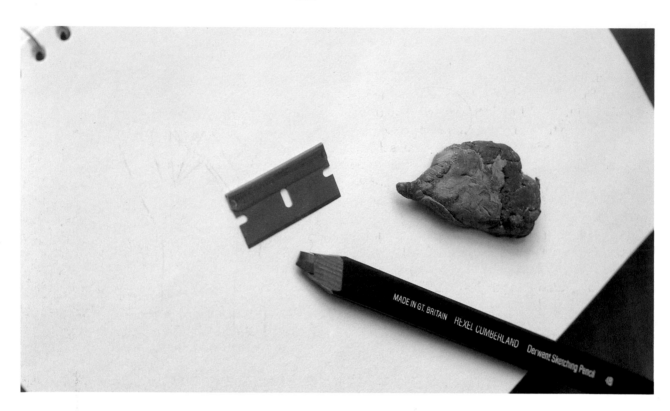

Your tonal sketch is part of the vitally important thinking period before you start on your finished painting. Art students everywhere pay lip-service to and agree totally with this concept – then they ignore the practice completely! Their only reaction is a sense of guilt because they haven't done it! They then wonder why their paintings don't progress as they should and why their pictures get rejected by exhibitions such as the RI. After all, they know that their washes have been put on cleanly and freshly, so where are they going wrong? Acceptance committees these days have so much to choose from and they expect technical competence at the very least. What they are really looking for, apart from an unusual slant on a subject, is a sense of cohesion and unity in a painting, and the only way most of us can achieve this is by thorough preparation.

To do tonal sketches properly, you need several more materials than I mentioned in Chapter 2. Let's call it your 'designer kit'. This

Above
All you need for your design kit is a 6B carpenter's pencil, a sketch pad, a razor blade and a putty rubber, then you're in business.

Below
This shows how much variation in tone can be obtained by varying the weight on the pencil.

consists of a sketch pad of smooth cartridge
paper (don't try to do the sketches on your
watercolour paper, it's unsympathetic and won't
work – you can't get the range of tones). Next
comes pencils. Many people use HBs, which
are more suitable for writing. What you really
need are good soft pencils from 3B to 6B, and a
6B carpenter's pencil. These are better as they
discourage you from drawing lines around your
subjects. Apart from a putty rubber, that's all
you need.

One of the first things you have to learn is
not to draw lines – I call them wires – around
everything. Artists may be inclined to do this
because they were taught to do so at school.
Lines are utterly unhelpful and have no place
in a tonal sketch. There is also an inclination to
use the same pressure on the paper through-
out. Again, this is wrong and simply won't
work. You must get into the habit of using
varied pressure from, say, ½oz (14g) to ½lb
(225g) to get the full range of tones you'll need.
You should also avoid making your tonal
sketches too big: 2×3in (5×7.5cm) if done prop-
erly will be enough to tell you whether or not
your initial design is properly united and suc-
cessful. If not, then try another one.

Avoid putting in any detail whatsoever, an-
other great temptation. At this stage you mustn't
think of the components as objects, but merely
as areas of tone. Simply ignore window frames,
tiles, grasses and the like. Concentrate on the
overall pattern and then set it down in mini-
ature. For the cost-conscious artist, you'll be
saving thousands of sheets of expensive water-
colour paper through failures in the years to
come.

I should say here that I prefer to do my tonal
sketches in burnt umber, simply because I en-
joy handling paint. However, the pencils are
much easier.

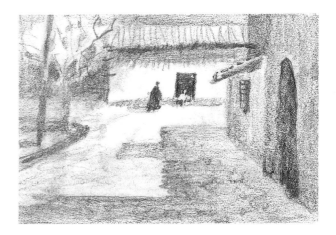

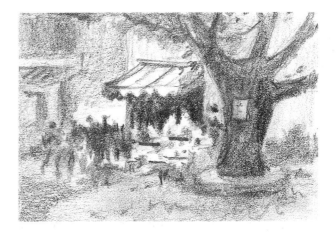

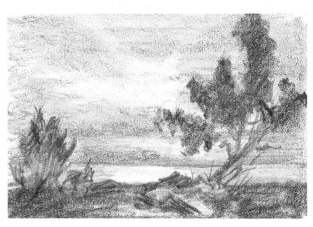

On the right are three typical tonal sketches; they take only minutes
to do after some practice, but are vital to improve the design of your
paintings.

COUNTERCHANGE

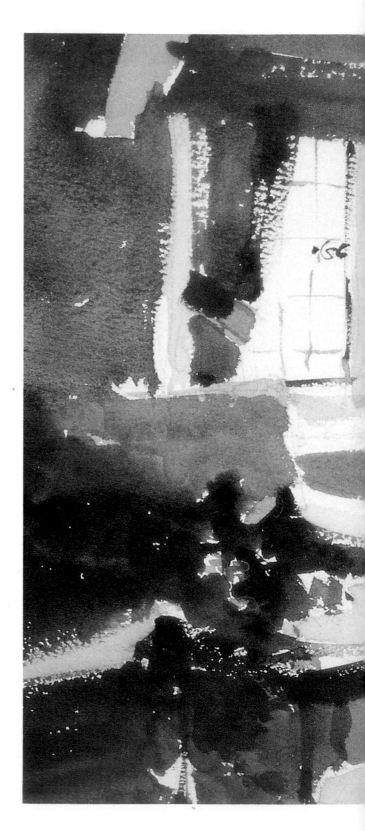

Those of you who have read my previous books or have been on my courses will probably groan when you see the heading for this chapter. Yes, it is one of my hobby horses! I see so many flat-looking paintings in art society exhibitions where the artist has simply not understood the principle of counterchange. Some of my students who have nodded wisely as I've pressed the point home, have forgotten the whole thing when they are out on site, face to face with their subject. They don't realise that they have to work actively at counterchange, even though it may not be obvious in the subject. After all, you can't expect nature to think for you. It really is necessary to intensify the values and contrasts more than are actually there.

Moving to the other end of the scale, every one of the fine artists in Chapter 1 knows the principle of counterchange well and exploits it in every picture. I've taken the opportunity here of showing another of John Yardley's pictures which illustrates so well the points I'm trying to make. If you've seen my book about John Yardley (David & Charles 1990), with its hundred or so illustrations, then you've had an even better chance to see his masterly use of the concept. It really is well worthwhile to spend time looking at the work of the masters and to analyse where they've used the technique. So now, let's go over it again. The basic idea behind counterchange is very simple. It's the placing of dark shapes against adjacent light shapes and light shapes against dark. Although this sounds very straightforward and sensible, it's amazing how easy it is to forget as soon as you start your painting.

WAITING by John Yardley
I can think of no better way of illustrating counterchange than by showing one of John's powerful yet simple watercolours. The design pattern makes the picture 'read' with very few strokes, using adjacent darks and lights throughout the picture.

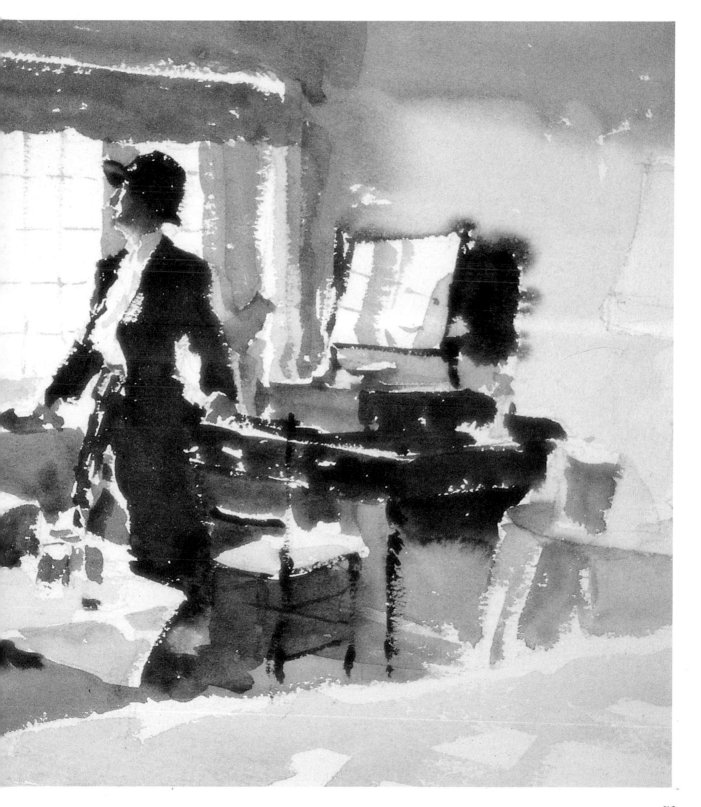

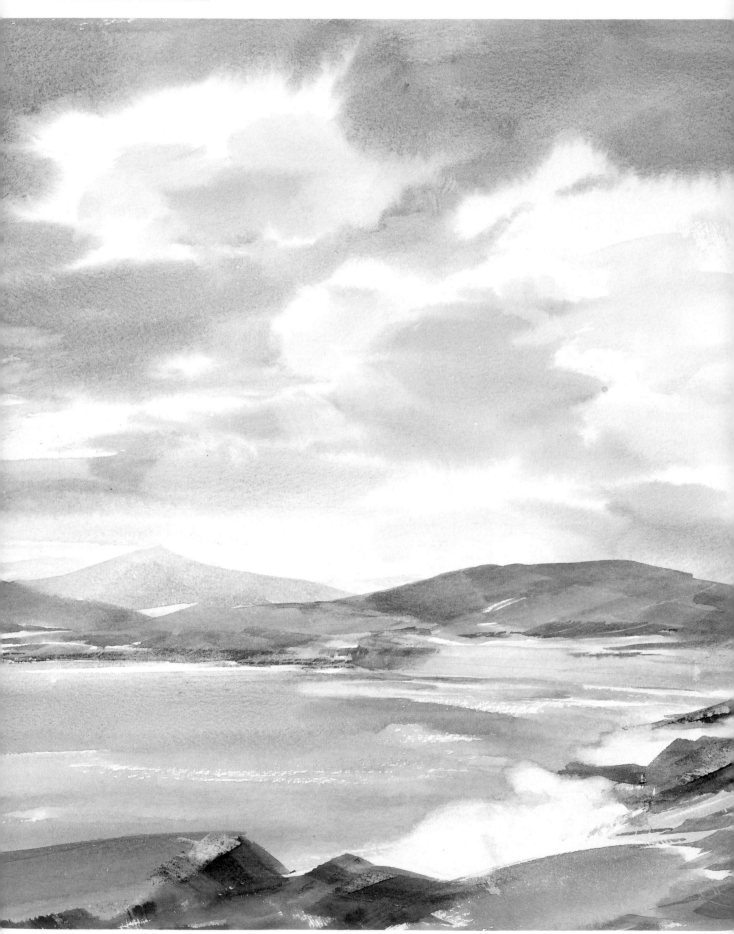

Counterchange is the easiest way of stressing the main centre of interest in your picture. To do this you simply place your darkest dark subject against you lightest light one, which will immediately draw your viewer's eye towards that area. Having said this, the principle should be at work in a less obvious way all over the picture. Do remember, though, that these effects won't be achieved by accident. You must think your picture through beforehand – you can't expect to do it as you go along. (Now of course, we've come back to the tonal sketch, a vital preparation for any and every painting you do.) A good test for whether or not your counterchanging has been successful is to photocopy your painting. This will eliminate your colours and reveal only the tones. If the overall effect is flat and confused, then you must think again. There really is so much that you can do to improve your work before you start on your finished painting.

Why is it, then, that so many students feel that counterchange is a waste of time and want to leap in with full colour? This is one of the biggest things that separates the amateurs from the professionals. I don't apologise at all for repeating my advice on counterchange. Get the idea of counterchange firmly and permanently into your brain and your work will improve by leaps and bounds!

Here counterchange is used extensively both to indicate the shapes of the rocks and hillsides. In the case of the hillsides, this is much more subtle, with minor changes of tone, whereas in the foreground rocks you have a very strong alternation of lights and darks.

SKIES

Constantly changing, the clouds for ever on the move, skies are one of the most exciting and challenging subjects for the watercolourist. Skies are not an easy subject and require lots of practice, but your hard work will be richly rewarded when you produce your first convincing sky.

In Victorian times, students were told to do at least one sky every day of the year. Now, however, with all the rushed pace of modern life, this probably isn't practicable; but even two or three a week would amount to a hundred or so in a year. After that you should be able to see a sky in watercolour terms.

One of the good things about skies is that you don't have the worry and the problems of drawing and perspective. You're left free to concentrate on the simplification of the patterns. Skies are never static so you must find the essential feature and simplify it. Don't worry, you'll soon be able to develop a free style. After all, you don't have to go out and look for your subject. It's there waiting for you just outside your window.

Don't start a sky painting until you're clear in your mind how you're going to tackle it. As with any other subject, think first, paint quickly, and get out fast. It's so tempting to 'worry' a sky to try to improve it, but if you do, you'll lose the transparency and spontaneity. If it doesn't work the first time, take out a fresh piece of paper and start again. The sky is always the first thing you paint in a picture so you won't have wasted too much time!

Courage is an essential factor in painting skies. One of the chief faults is timidity. No one seems to realise that skies will fade back as they dry – if it's right when it's wet, it's wrong when it's dry! In other words, always make your skies stronger than you think they should be – that way they'll probably finish up right! You've probably noticed, as I have, that many watercolour books quickly gloss over the subject of skies, which is a pity because the sky will make or mar the picture.

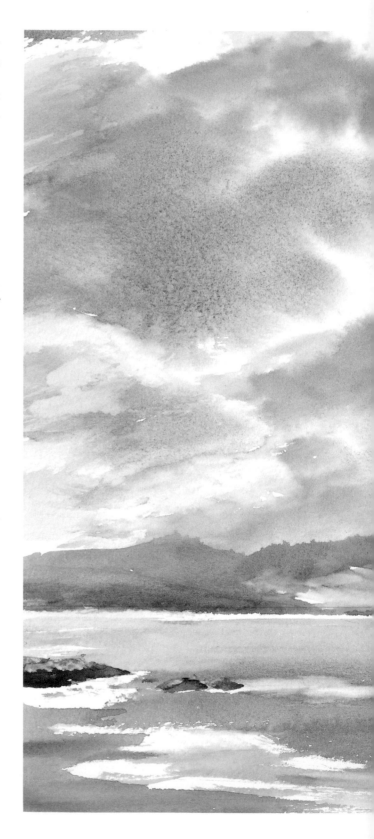

This strong cumulus sky was a real challenge. I wanted to introduce more warm colour into the clouds which would be reflected in the sea. I've also tried to show the shadows cast by the clouds on the headland. Look too at the way the clouds diminish in size towards the horizon. Tackling a sky like this is something of a tightrope act and depends for its success on timing and water content. First I put on a pale raw sienna wash and indicated the clouds by using blue negative shapes, immediately adding the shadows, made from Payne's grey, alizarin crimson and, in this case, a touch of raw sienna for warmth. A picture like this must be spontaneous. If it doesn't work first time, throw it away and start again. Touching up will only ruin it.

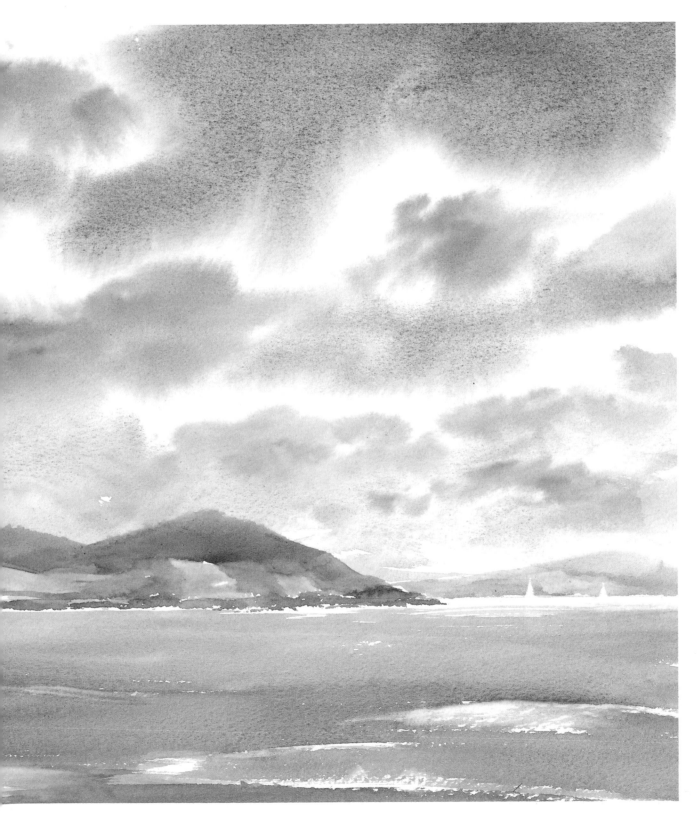

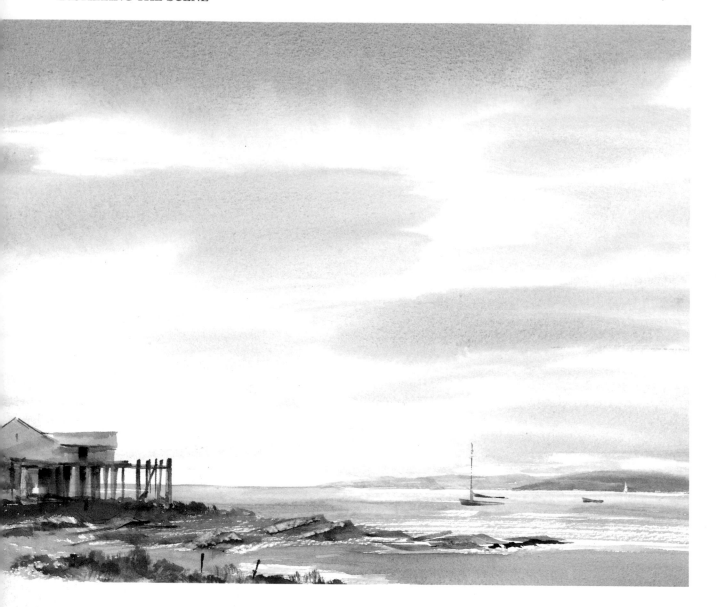

Painting Clouds

If you want to make your skies really convincing, you must learn the various cloud formations and conditions. Get into your mind, that from now on you're not just going to look at skies as most people do, you're really going to study them. Try to imagine how you would tackle them in paints – what colours you would use and how you would go about it.

Painting clouds outdoors is enormously challenging with changing light, moving clouds and uncertain weather. However, it really is an exhilarating experience once you get to grips with it. From my own point of view, I sometimes feel it's almost like cheating because I can produce almost half my painting in only a few minutes.

In any cloud formation, always make one of the clouds dominate the rest. This is one of the principles of design and it always works. Remember, as the clouds recede to the horizon, they decrease in size. You'll notice that clouds on the horizon are only a fraction of the size of those above you.

Don't ever think of the sky as just a background to your landscape. Not only is it the source of light but it governs the whole mood of the painting. What you're aiming for is to get your basic knowledge of skies outdoors, but also to be able to carry that knowledge back into the studio with you, so that eventually you will be able to produce skies out of your head. A good sky will enhance any subject and can transform the most mundane landscape into something really special.

This painting of a cirrus sky is comparatively simple to do, but again relies on timing – thirty seconds should do it! First put on your pale raw sienna wash and then with good confident whole arm strokes, add the blue. The streaks should become narrower and closer together as they reach the horizon. Make sure that the blue at the top of the sky is strong, decreasing your pressure on the brush as you reach the horizon to lighten it. The idea here is to create the feeling of light and space.

Here we're confronted by an entirely different situation – a threatening sky and approaching rain. This scene needs a variety of colour if it's to avoid monotony. Boldness is absolutely essential, together with speed. Again, I began the sky with a weak wash of raw sienna, this time adding lemon yellow for brilliance. Next came a rich mix of Payne's grey and alizarin crimson with which the main shapes were swiftly indicated. To this I added a secondary wash of light red and burnt umber to give variety to the distant clouds, leaving the sky nearer the horizon yellow, which reflects beautifully in the background water.

My own favourite artist, Edward Seago, lived in Norfolk, a county which is flat and to the casual observer the subject matter may be considered rather dull. Seago, however, could produce magnificent paintings using a tiny gate or a tree with 90 per cent of the picture being sky – but what skies! Looking through old catalogues of his exhibitions will show you that a lifetime of studying skies has reaped huge rewards.

Incidentally, one of the many things I learned from studying Seago's paintings is that cloud formations can be used to balance up a picture. For instance, a dark boat in the right-hand foreground of a picture can be balanced by a cloud formation in the top left.

Don't neglect photography either. Build up your own collection of sky pictures. Whenever you see an interesting sky or a good cloud

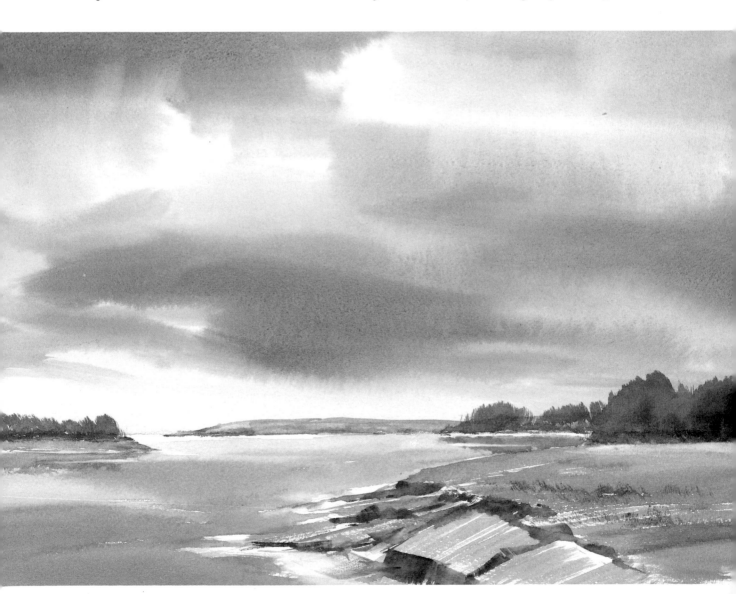

formation, grab your camera. Forget the landscape and just concentrate on the sky. The process will also sharpen your awareness of skies and clouds. I often find, too, that black-and-white pictures are more effective, but in this case it's advisable to use a red filter which darkens the blue area and heightens the tonal contrasts of the clouds. When you're doing this, be careful of the glare of the sun. Use a lens hood or position the sun behind a building or tree.

Photographing skies, though, is only one aspect of your studies. The best way is still to go outside and make rapid sketches either in pencil or in watercolour. The more you do this the more quickly you'll come to understand how cloud formations which are parallel to each other appear to vanish to the same horizon line, in just the same way as the land and sea.

A sky subject which holds a great fascination is a sunset and, of course, Turner was the master here. However, without great care this is a subject which can quickly become a cliché.

This is a good example of how a picture can be balanced by the use of a strong, heavy cloud on the opposite side to the foreground hill. Don't be frightened of doing such a cloud, it may look horrifying when you first put your rich wash on to the initial raw sienna, but will soon fade back. It you want the feeling of approaching rain, tip the board up almost vertically for a few seconds.

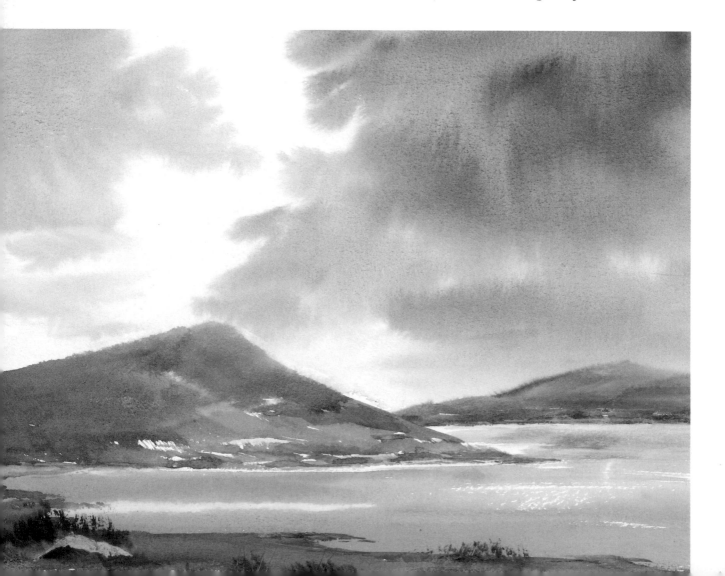

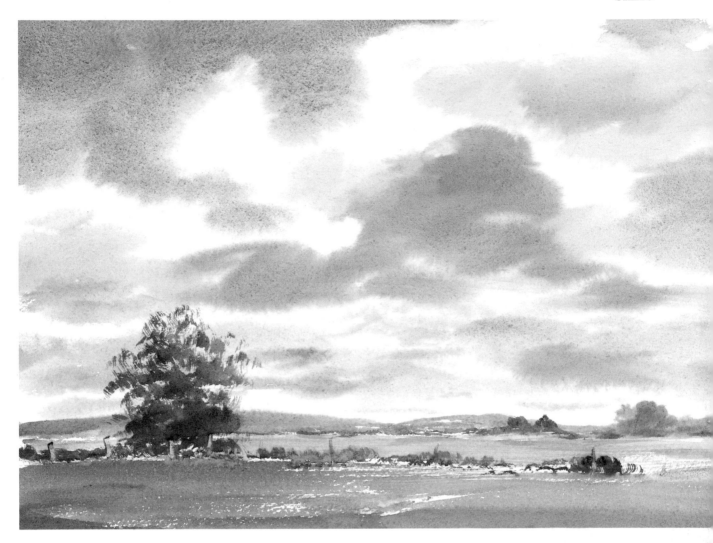

Never make your sunsets too garish, always err on the side of subtlety. You have to work very quickly too, because of the swiftly changing light.

When you're painting skies, always remember that the rules of composition apply just as much here as to the rest of the landscape. As I mentioned earlier, one cloud should dominate, but don't put it in the middle or on the edges of your picture. Another design feature which works well is to place a group of trees to echo the shape of a cloud. This will create visual harmony in your picture. I can't emphasise enough that the main reason for failures in sky paintings is a lack of forethought about composition. A good test is to look at the painting upside down or through a mirror, which will quickly show up the faults. At all costs avoid painting a row of identically sized clouds. This always looks really amateurish and simply mustn't happen.

When painting cumulus clouds, it's impor-

In the case of this picture, the cloud shape not only counterbalances the tree but echoes its shape, another good design feature. Notice the contrasting techniques between the soft sky and the crisp, rapidly painted foreground with its areas of untouched paper.

tant to realise that you're painting negative shapes formed by the blue sky behind them. Although this sounds obvious, it's a matter of confusion for many students, so do sort it out in your mind before you start painting. The space of blue sky between the clouds can become more dominant than the clouds themselves, so you may have to lighten this to harmonise the composition.

Cirrus skies are basically soft and feathery abstract patterns and are less dominant than cumulus clouds. They need great delicacy of stroke and the direction of movement is more important than their background shapes. Here again, you must give consideration to the spaces between them, which are an integral part of the composition. I find with cirrus clouds that speed and boldness of strokes are very important. Hesitant strokes will not be successful.

Another point to remember is that where there are clouds there are also ground shadows. These shadows can create excitement and drama in your painting. Think of them racing across a hill or covering a group of farm buildings. These shadows are, of course, elongated and diminish in size and grey down with recession.

What you're aiming for is harmony and compositional rhythm between sky and landscape, so get out there and practise!

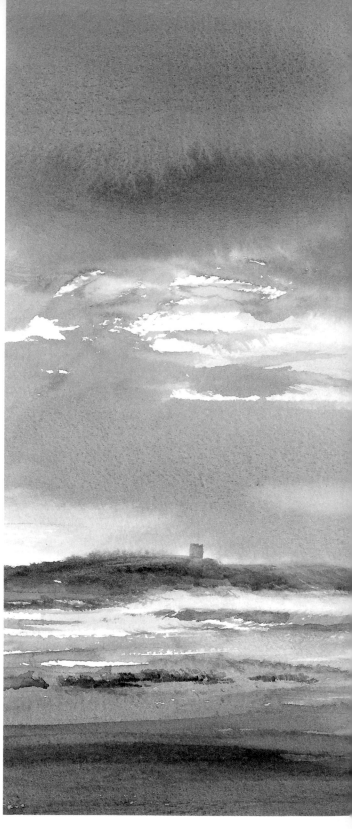

Left
This is an example of cirrus clouds, which incidentally usually occur at about 30,000 feet. They're quite harmless, but do help to break up an otherwise flat sky for the painter.

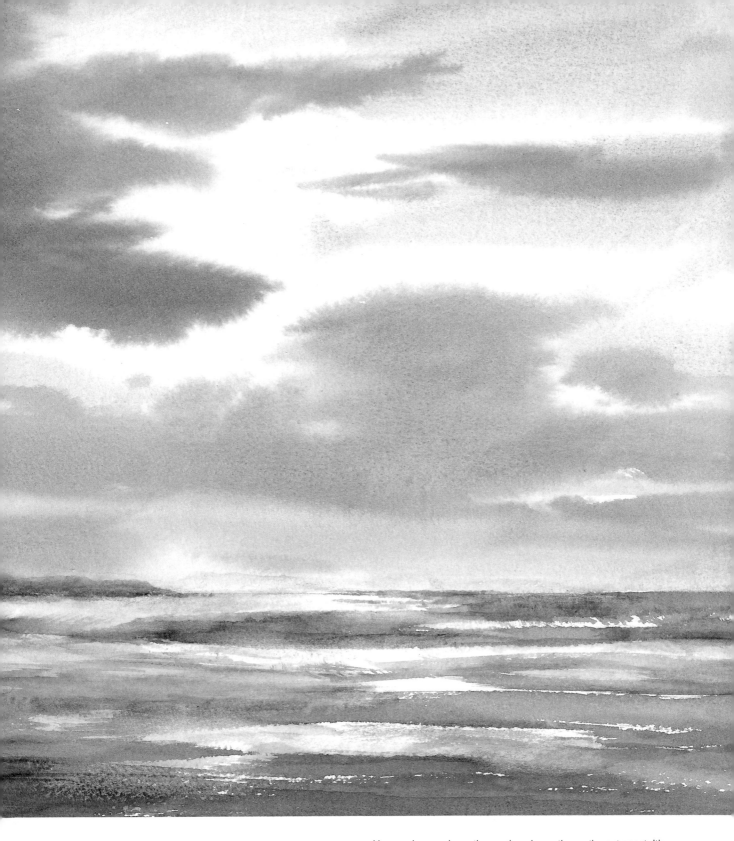

Here we have a dramatic evening sky on the north-east coast. It's surprising that, with all that turbulent movement in the sky, the eye should be drawn to the tiny church, just because it's the only man-made feature in the scene. Do let yourself go on a project like this. You'll find it really exciting.

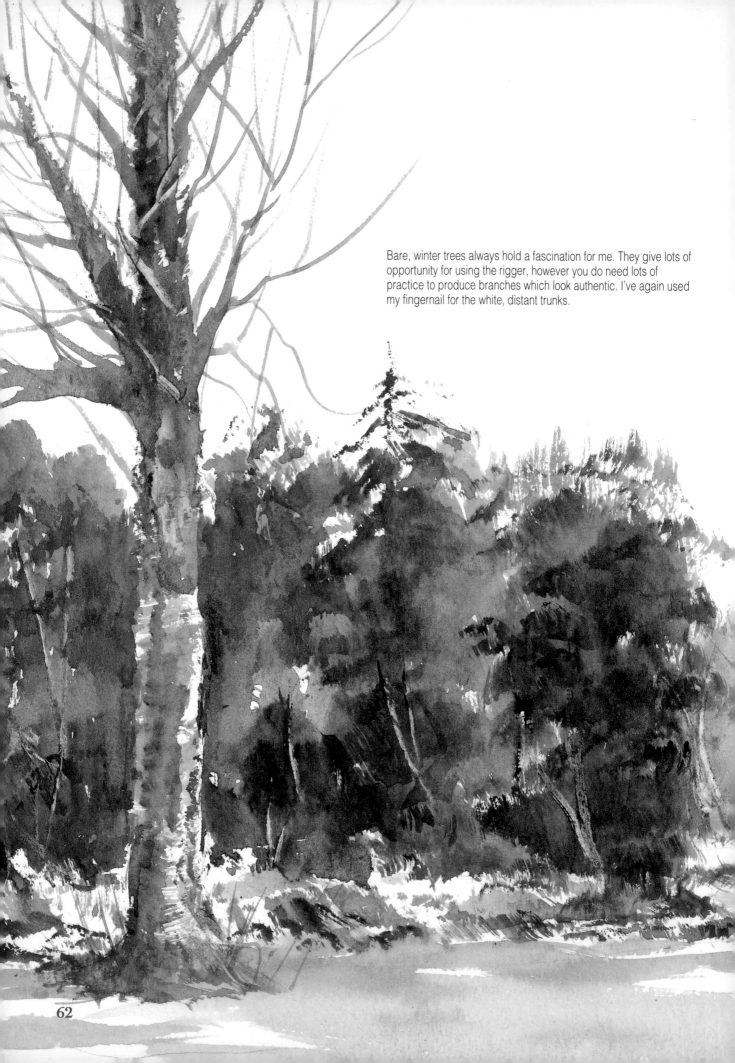

Bare, winter trees always hold a fascination for me. They give lots of opportunity for using the rigger, however you do need lots of practice to produce branches which look authentic. I've again used my fingernail for the white, distant trunks.

TREES AND VEGETATION

It can be a daunting moment when you come face to face with masses of foliage and vegetation and you have to try to convey all that atmosphere and flavour in watercolour. First of all, you have no chance of portraying it in detail, nor would you want to. So, the first thing to do is to screw up your eyes, which will get rid of the detail and you'll see the scene in much broader masses of light and shade. However, you still have to convey a sense of depth to your painting. The amount of texture you put in is very much related to the distance. For example, a distant woodland is best illustrated by one simple flat wash with no attempt to show any detail. If it's on the skyline, I often put it in before the sky is actually dry, which will give a soft edge to the overall top profile. I normally use a very cool colour to emphasise depth and distance.

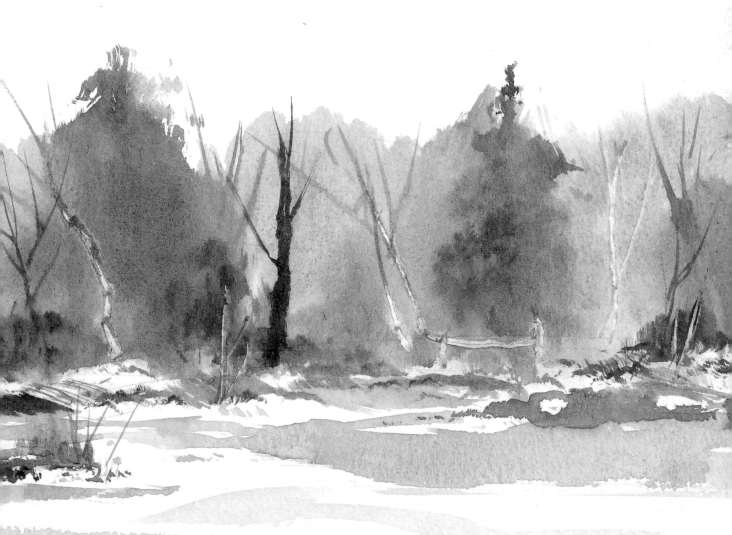

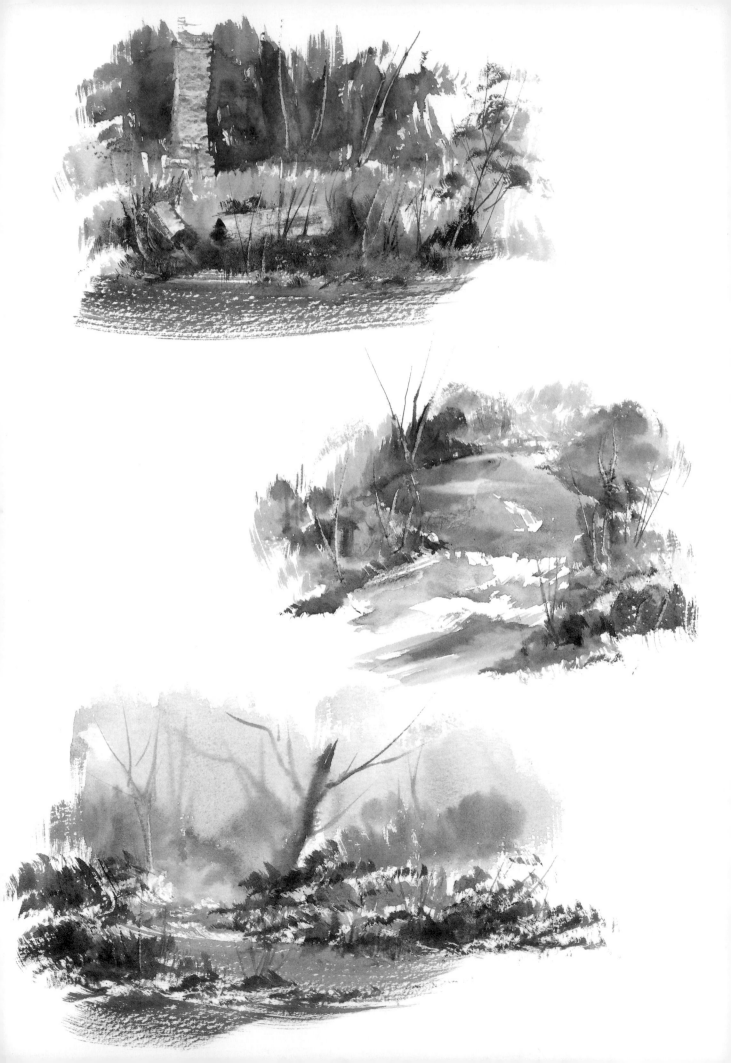

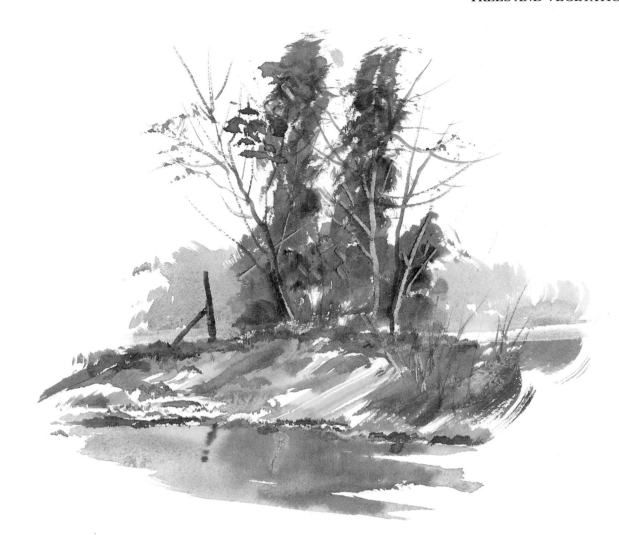

The vignettes on these two pages show how I try to handle woodland scenes using various techniques. You'll see examples of wet into wet, fast strokes of the hake in drybrush and the use of the fingernail in still damp paint to indicate grasses and tree trunks. I've even used a credit card for the tops of the rocks.

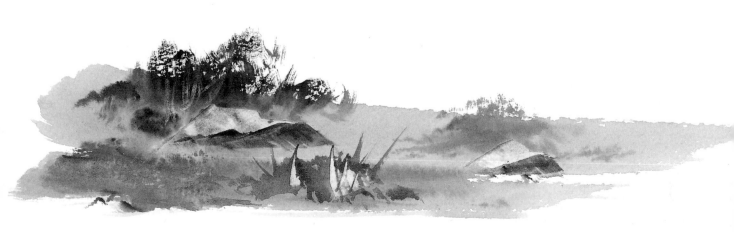

65

Moving forward to the middle distance, you can use more colour variation and slightly richer colours and a hint of texture – say, a few counterchanged trunks.

Moving forward again, in the foreground you can really let yourself go using your skills in the various techniques to illustrate the wealth of texture. A word of warning, though, as this is where the danger comes in. So many pictures face ruination at this stage through overworking. My own way of avoiding this is to work as fast as possible using few strokes but plenty of vigour and plenty of variety in paint thickness. I enjoy the feeling of putting in an almost dry brush with almost neat paint. To avoid getting it too spotty, however, combine the stippling effect with broad fast sweeps of the brush to hold it all together. The work on this page will illustrate this quite well. You may notice that in every case I've used cool colour in the background and warm rich colour in the front of the scene. Perhaps I've exaggerated this a bit to emphasise the depth.

I'm inclined to use a lot of wet-into-wet technique for the background, with blurred rigger work gradually adding definition and strength as I move forward through the painting. I also use literally anything that comes to hand – even my fingernails and knuckles in the damp paint! The flicks of the fingernail must be done with discretion and they're impossible to do if the paint is too wet as they'll just fill in. The knuckles I reserve for providing foreground texture. John Blockley once told us that he used the elbow of his sweater!

Remember also that a quick light stroke of the hake – and I do mean quick – can convey more excitement than ten tentative touches with any other brush. In general, I use just the hake and the rigger for vegetation. Although completely different brushes, they seem to be an ideal combination for this purpose. Don't underestimate the skill needed for the rigger. It should be held very lightly, the weight on the paper being of paramount importance. Pressed down it will convey the trunk of a tree, while a light touch will produce the most delicate twig.

Be aware constantly of the effect of counterchange. Show white or light trunks or grasses against a dark background and dark trunks against pale objects. In general, the undergrowth and ground are lighter in tone than the trees behind.

This is an autumn scene on the shores of a lake in Vermont where was teaching recently. You can see that the far distant trees are painted wet into wet to push them further back, whilst strong, rich, almost neat paint has been used in the foreground for impact. Again note the reversing of the tree trunks and grasses using the scratching out method with the fingernails and brush ends.

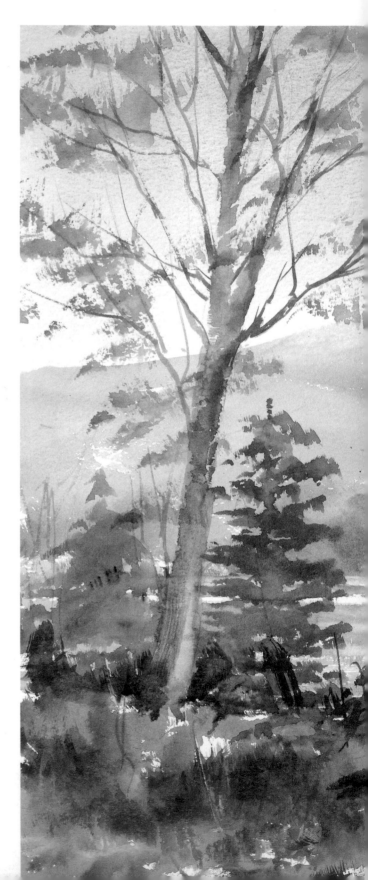

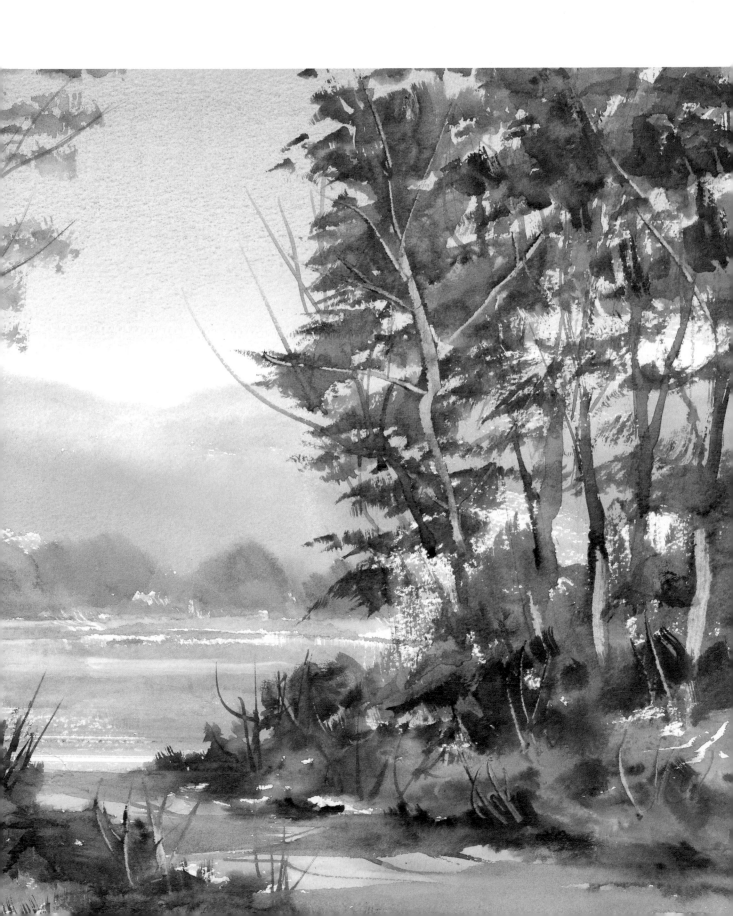

DISTILLING THE SCENE

Used in the right direction, the hake can easily convey sloping banks, vertical trees or flat ground. Again, notice from the illustrations how I've tried to use this in my paintings. One thing to be avoided at all costs is the cardboard cut-out effect, caused by making trees, etc, too hard-edged. Try to get a light frothy effect with plenty of sky holes around the edges of your trees, bushes, etc. Merely indicate the supporting branches in these sky holes and avoid painting the branches on top of the massed foliage – very much a beginner's mistake. Nothing else is changed in appearance by the seasons as much as trees and vegetation. You can produce entirely different effects by changing your range of colours. A good idea is to try to produce the same scene in different seasons.

Finally, don't neglect the shadows. Dappled sunlight across rough ground can increase enormously the interest and attraction in a scene.

So I hope you'll agree with me that in this chapter particularly, the paintings speak for themselves, more than any words of mine.

Opposite
This is an example of the effects you can get by using strong contrasts and counterchange; for instance, dark branches against the warm distant light and light grasses against the darker foliage.

Below
This is another demonstration painting done on the beach on Sanibel Island in Florida. The main feature is the group of delicate Australian Pines which grow right on the beach. Notice the warm shadows and the rich foreground texture contrasting with the cool distance.

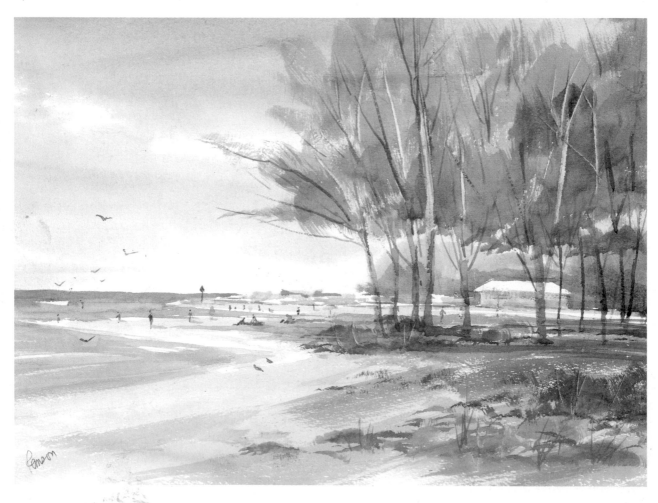

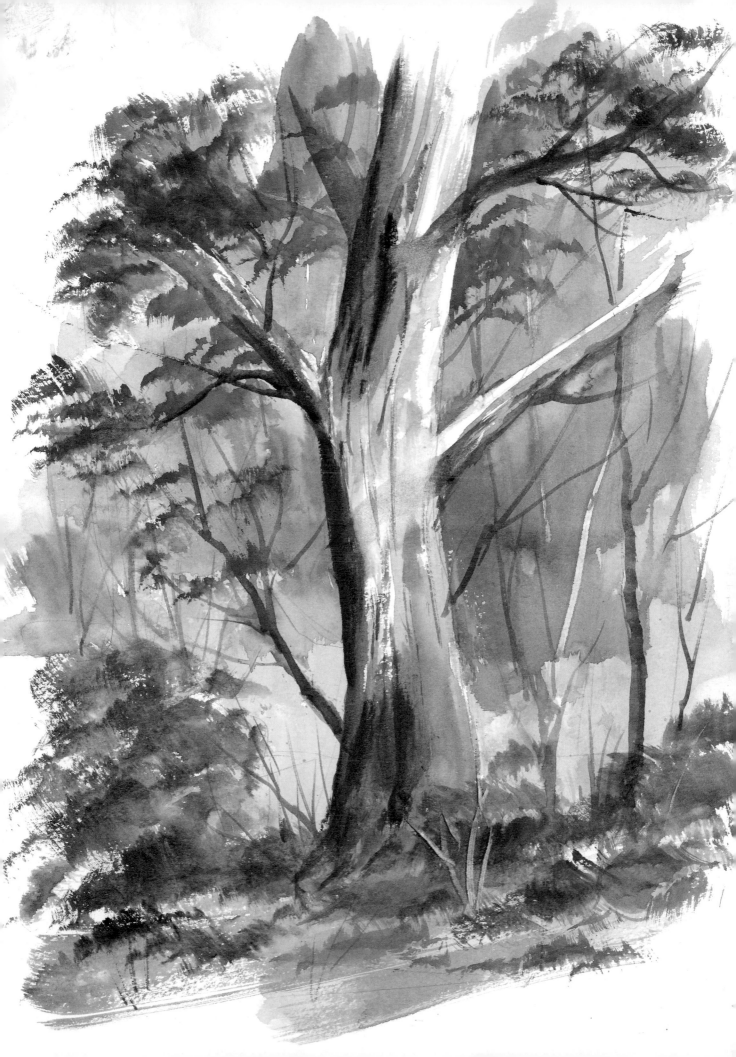

10

BUILDINGS

Given the right attitude of mind and with help from the hake, it's relatively straightforward to simplify or 'distil' subjects such as trees, hills and rivers. However, when it comes to buildings, you have more of a fight on your hands, psychologically speaking. Certainly I've found with my own students, that while one half of the brain is determined to indicate buildings in as simple and economical way as possible, thus relating them to the rest of the landscape, the other side of the brain is saying 'Wait a minute, unless we carefully paint in bricks, stones and window frames, my audience won't understand it'. This is in spite of the fact that the students themselves love, admire and perfectly understand the buildings painted by, say, the French Impressionists. This is very much in my mind at the moment as I've just returned from a painting holiday in the Italian lakes. My students and I have been staying in a tiny but lovely old town, where we've spent ten days painting in the square and narrow streets.

During the first few days, there were the usual problems with perspective. These were mostly caused by angles of gutters and bases of houses and can be cured fairly easily by holding up your pencil in line with the angle, and then taking the pencil back to the paper at the same angle. Once you've learned this trick, you'll be surprised at how quickly things will improve. Without it, gutters and roof lines can be very deceptive.

Another obvious fault is a depressing deadness in the colours of the buildings. For example, the side of a wall may be discerned as fawn, so a careful mix of weak burnt umber is

Demonstrating in a town or city definitely helps free your style, for the very good reason that if you spend time on architectural detail, your students would walk away bored! I've put in only the essentials, whilst varying the colour in the walls as much as possible.

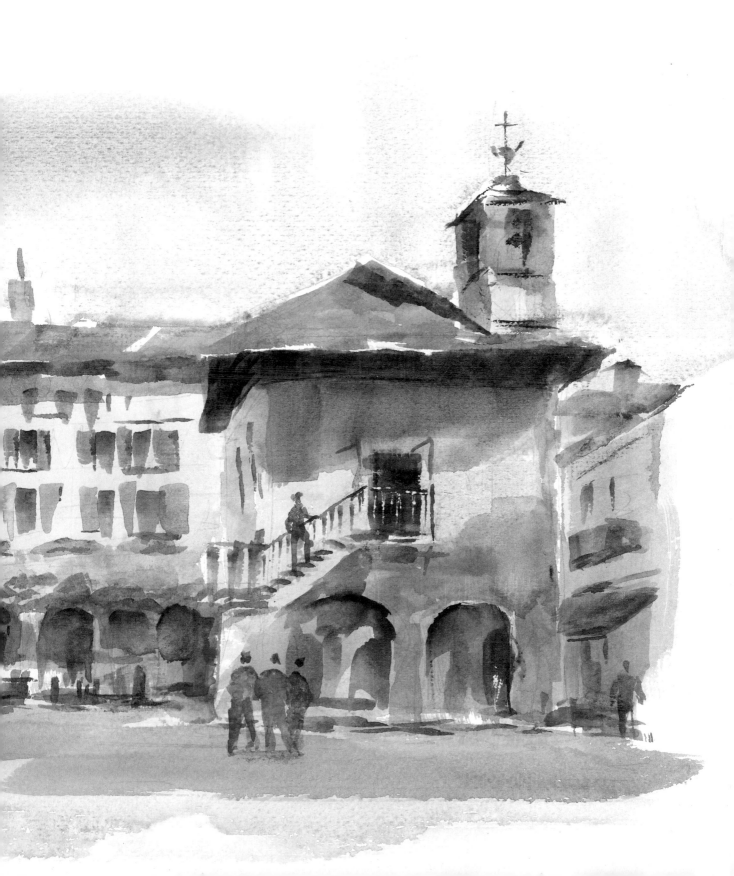

used to paint it. Then the ground is painted grey, as is the roof, even though it is drenched in sunshine. This, of course, will produce a very dull and lifeless painting. I've never forgotten that when I first went on a painting holiday in the Pyrenees, the instructor looked at my picture and said that I was painting Spain like the Yorkshire Moors. To avoid all this deadness, you should warm all your building colours and vary them in both tone and colour. A single wall may have many colours introduced into it (see p73). It's reasonably easy to do. Once you've mixed your overall wash, add other colours as you cover the paper. By doing this you'll avoid boring your viewer, not to mention yourself.

Counterchange in a building is very important, too. Don't be afraid to use strong darks underneath to throw up a sunlit awning.

I find that when putting in shadows, it's often best to wait until the end and then put them in quickly. My own favourite mix for this is half-way between ultramarine and light red. Keep them very transparent, letting the underneath colour show through. Try to do it in one go without retouching the wash.

Another technique which can sometimes be useful is to put in windows before the colour on the wall has dried completely. This will give a soft focus look which is useful particularly in an area that is well away from the main object of interest. I learned this from studying Edward Seago's buildings.

Another idea I tried on my Italian holiday which was quite successful, was to cut down my pencil drawing to the very minimum, when I began to feel that my painting was getting too tight. Day after day, I was playing a psychological game with myself to attain this spontaneity, even with complicated buildings. On some occasions, I even tried townscapes with no pencil drawing at all, attacking virgin paper directly with the brush. It needs a strong nerve, but when it comes off it's really exciting. Talking through the paintings to my students as I went along was also helpful – it made it impossible for me to fiddle and overwork!

I also discovered that my students were reluctant to add figures to a street scene in case they spoiled the whole painting. This is a great pity as figures give scale and add animation. Remember that if you're standing painting, all

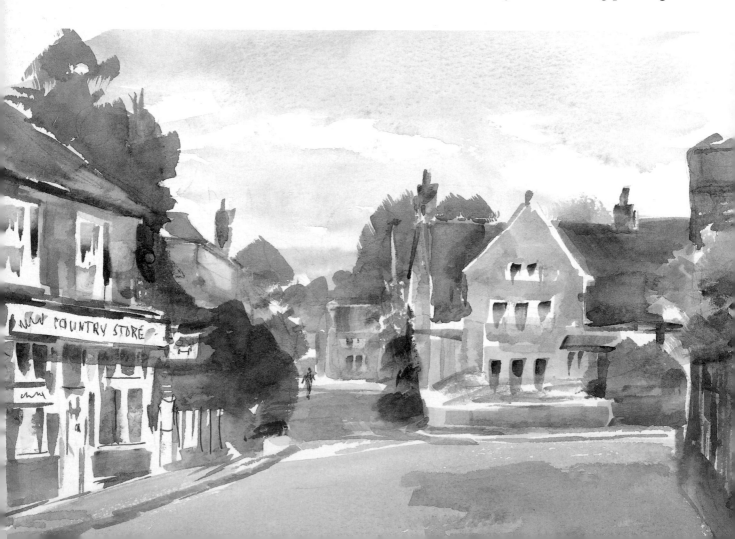

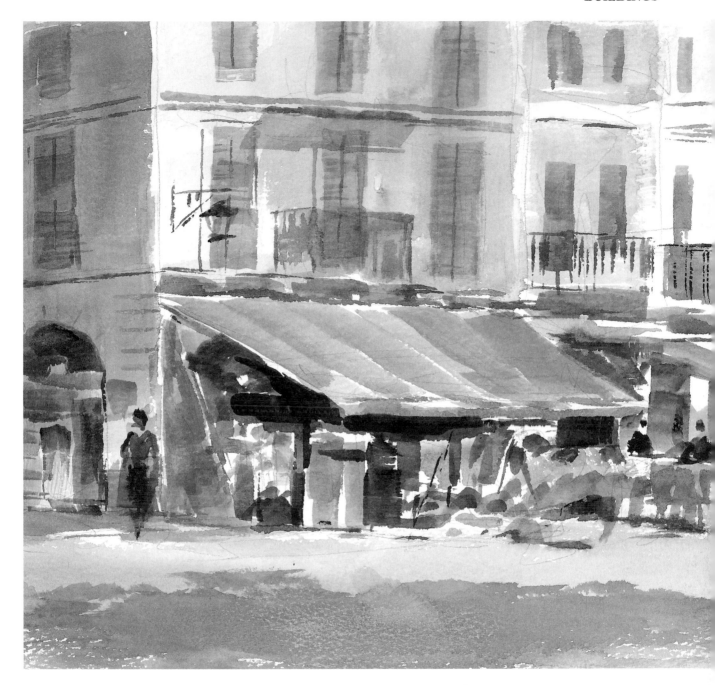

Above

This little sketch of a shop and café was painted in a town square. Note the lightly indicated shutters and balconies. I've tried to get subtle colours in the shadows, and to vary the colour in the awning. There was a mass of brightly coloured goods outside the shop which had to be greatly simplified.

Opposite

This is the village street in Wylye, painted as a demonstration for my students at Philipps House. Again I've tried to vary the colour on the walls. Perhaps the most interesting feature is the way I've left the white paper for the village shop, by painting in the negative shapes.

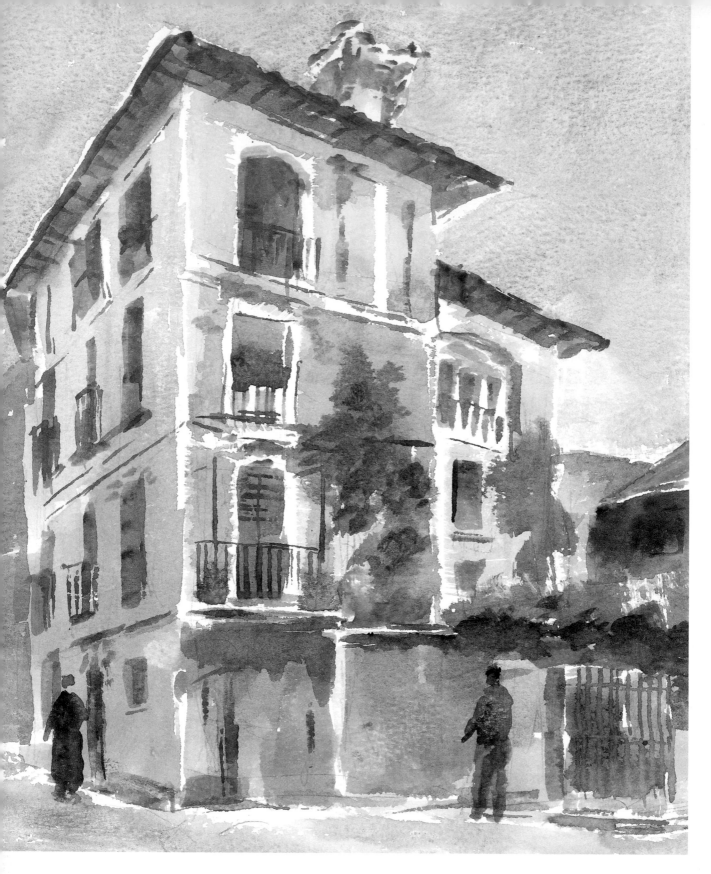

I painted the building from very close to with my back against a wall, so there's an acute perspective on it. Here the task was to indicate the character of the building with its fancy chimney, in a very simple way.

Opposite
This is a small sunlit garden with the mountains behind. The most difficult part was to indicate the white window frames very simply against the pink walls avoiding fussy detail. The interesting shadowed wall on the left caught my interest. I've used warm and cool colour here to avoid monotony.

the heads, whether near or far, should be on the same level. It's the bodies that get longer as they come to the fore. Once the students were persuaded to put them in, the figures were often too tight and stiff, so I insisted on a day devoted to turning out dozens of little figures drawn from café tables. The biggest fault was always making the heads too big. A tiny head with a slender body will look more professional. It helps, too, to put one or two light figures against dark areas in the painting, by using negative shapes around the figures. Study the figures in watercolours by Seago, Wesson and Yardley, for instance, and you'll soon see what I mean.

By the way, don't be afraid to put in a few bright colours, dotted around – pure yellow, red or blue. These can and do enliven any street scene.

Regarding detail, don't be tempted to paint all the tiles on a roof or all the slats in a shutter. These can be hinted at very simply, and the viewer can do the rest – it will add to their enjoyment.

Take risks! It's very difficult to get a spontaneous-looking building if you've spent hours drawing it. You'll be forgiven a few odd mistakes as long as the building is indicated with freshness and sincerity. Nothing will deaden a picture as much as over-correction. Regarding the brushes used, I find that the walls on larger buildings can be put in with the hake and, after that, most of the work is done with the 1in (2.5cm) flat, while the rigger is reserved for the figures.

Despite all the difficulties, by the end of our ten-day holiday, the overall change in attitude was terrific and the students went home with paintings of free and spontaneous-looking buildings.

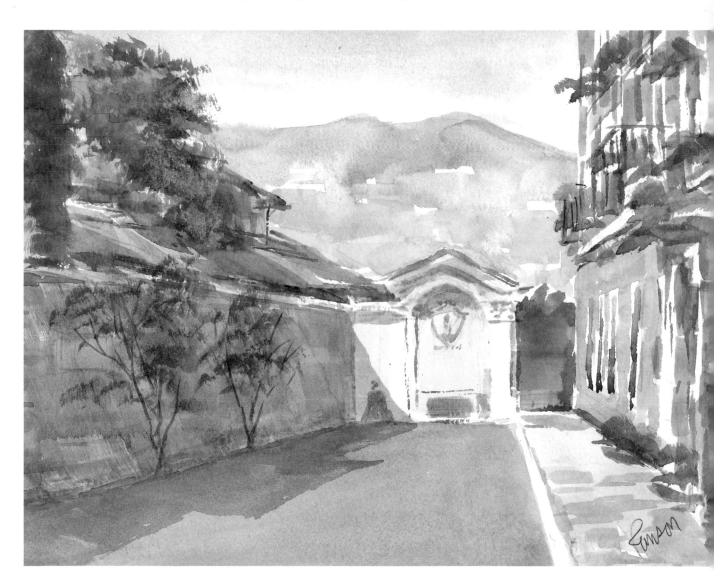

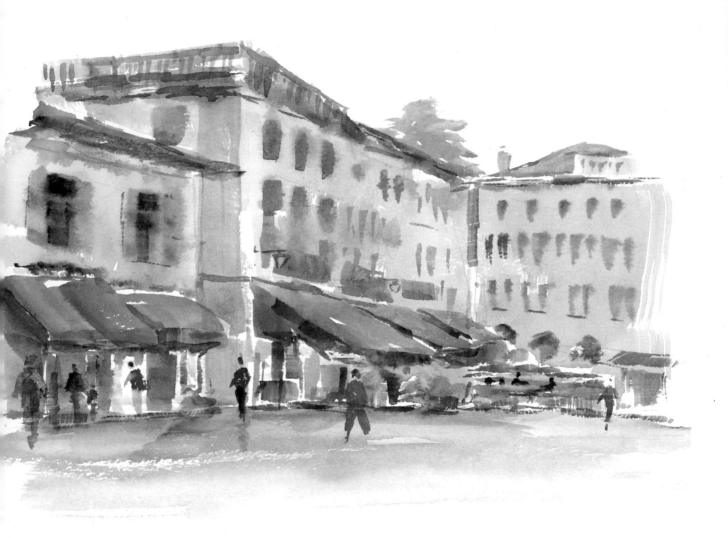

Another quick rendition of the town square – I was staying in the hotel on the right. Avoid painting the sides of the buildings grey, even if that's how they look. Look at the varied wash on the hotel. Each building has its own individual colour. It's also permissible to drop windows in before the wash is completely dry, which helps to create a 'free' atmosphere. This is one of many things I've learned from studying the work of Edward Seago.

Opposite
This building was a beast to draw! On a steep hill and up close, I certainly wouldn't recommend it to a beginner! It's always difficult to keep the freedom when part of your mind is telling you to put in all the details. It can become a real mental struggle.

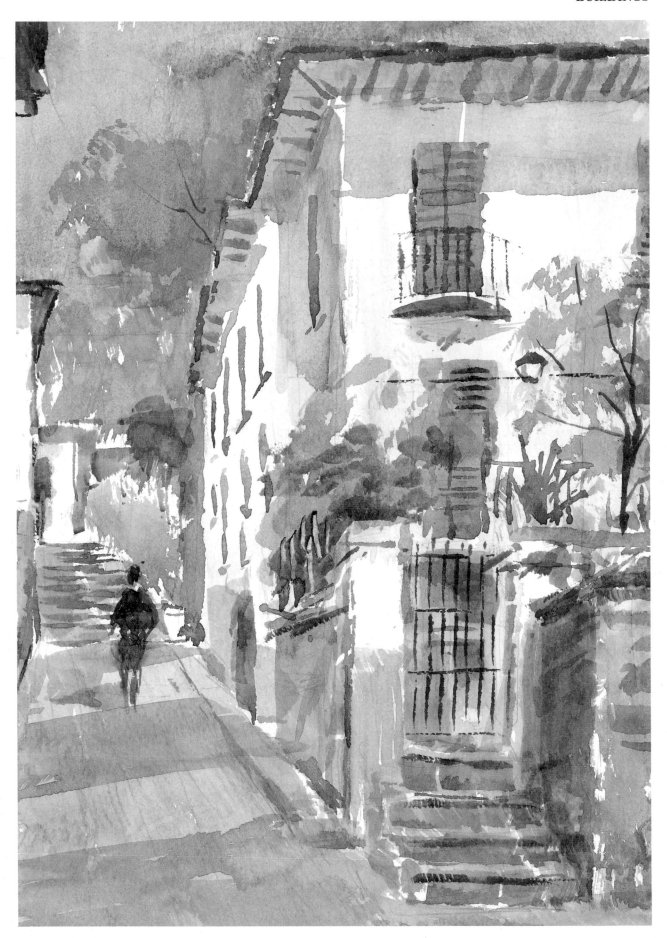

WATER

Although not as immediately available as
skies, most of us don't have to travel too
far to find water in at least one of its
moods. This for me is the fascination of water –
it has so many moods, so many contrasts, from
a quietly rippling brook to a raging sea. The
fascination is such that when I was moving
house, one of my main requirements was that
there should be water nearby. I finally found
the right property and my new house has a
beautiful brook running through the garden.

Water is the subject of a large part of about
70 per cent of my paintings. The greatest chal-
lenge is always to create the atmosphere and
the feeling of liquidity with as few brush strokes
as possible.

Let's start with calm water. You can virtu-
ally look on this as a horizontal mirror. Water
itself has no colour but reflects everything be-
hind it. The apparent colour of the water is
governed by the sky, whether it is blue or
stormy. For instance, a yellow sunset would
turn the water into liquid gold. Any trees or
foliage on the river bank will reflect upside
down, adding interest and depth to your pic-
ture.

The distillation process is more important
than ever here. Too much detail will ruin the
effect. You have to be constantly on guard to
avoid fussiness.

If the water is disturbed by a slight breeze,
the reflections soften and become blurred. My
own method here is first to put the colour of
the sky in the water and then drop in the
reflected objects with rich paint on to the damp
surface.

Remember the basic rule that dark objects
reflect slightly lighter while light objects are
slightly darker. In other words, the range of
tones is less contrasting in the reflections than
in the objects themselves.

As the movement of the water speeds up as
in a rippling stream or a fast-flowing river, the
surface of the water is broken up and you can
have a lot of the white paper showing through

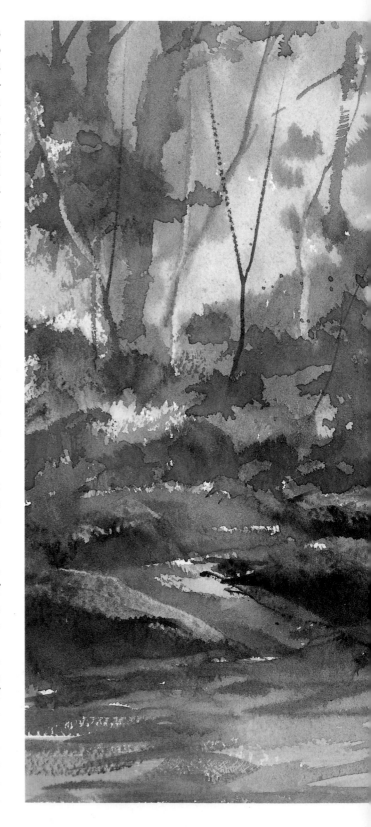

The object of this painting was to try and get the feeling of 'blinding light at the end of the tunnel' and the only way to get this effect is to build up the strong tones around it. It is no time to be 'afraid of the dark'. Also, try to get various colours into these darks – it is not easy. It is relatively simple at the beginning to mix the yellows and blues wet-into-wet to get the distant light. You then work forward from the background with richer, darker, almost neat paint. I also put some of the rigger work in at this stage. As the paper dries the front trunks will get sharper. Make sure that the colours in the background are repeated in the water, finishing up with a few fast sharp strokes on top when the initial wash of the water has dried.

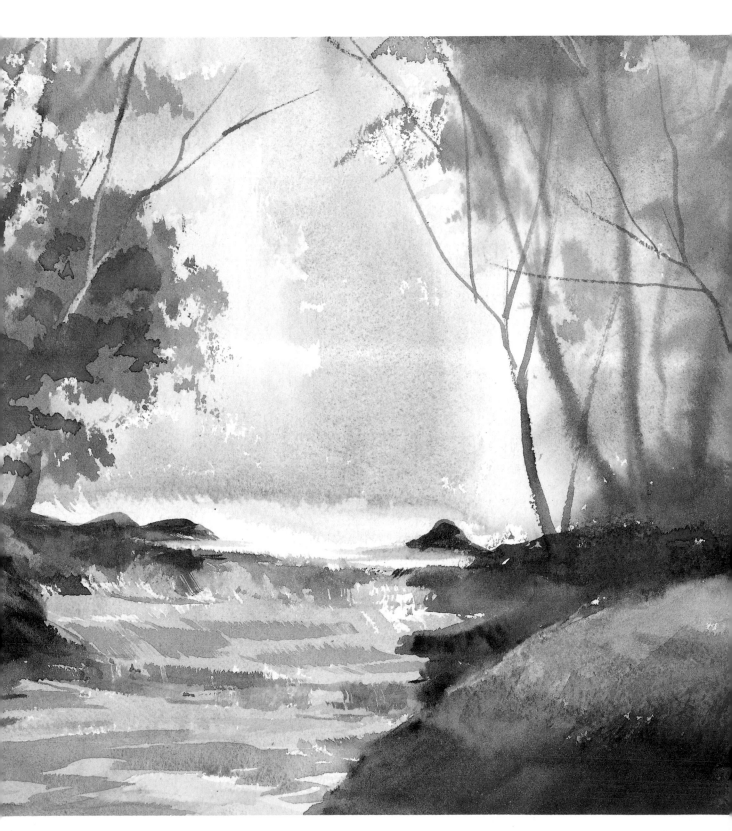

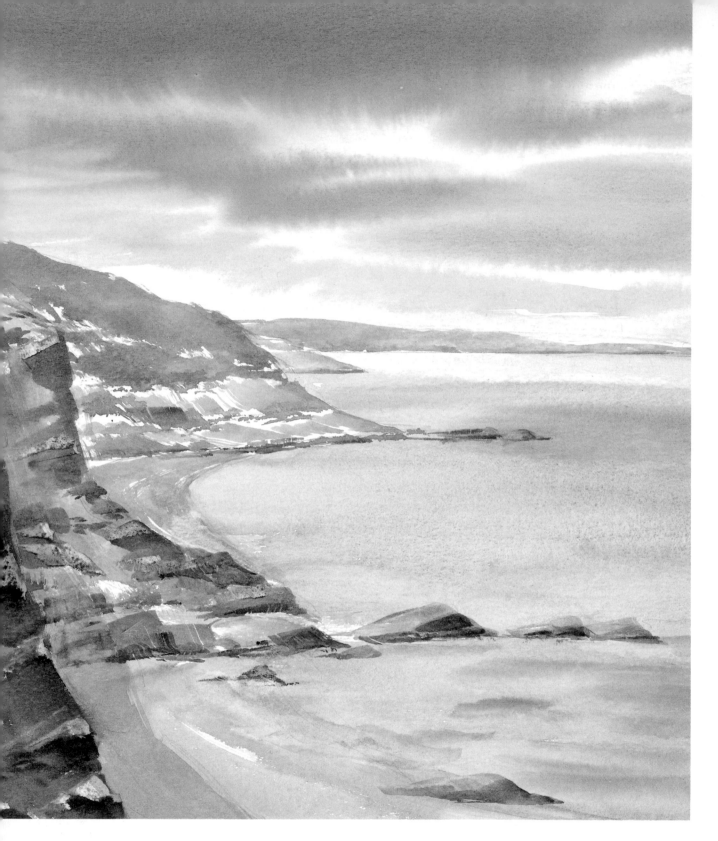

Above
This painting was done on a cliff top near Tenby as a demonstration. What I've tried to show here is the wide variation of colour in the sea. Looking from above, the sand on the seabed shows through, changing the colour completely and rocks too can be seen beneath the surface. Note the gradual change of tone and colour with each successive outcrop, and the shadow on the sea cast by the wet into wet clouds.

Opposite
A snow scene doesn't have to be cold. There's quite a lot of warm colour in this snowy river scene, from the yellow sky reflected in the water. This is another vignette, a form of painting which I enjoy (you don't have to fill in the corners!). It suits some subjects very well.

to indicate the flow. A good idea is to make quick, light strokes in the direction of the flow. The faster the river, the quicker and lighter the stroke. The hake is ideal for this method. With the water in this state you don't have to worry about reflections, although patches of colour and tone will still be reflected, such as a sunlit tree or darker undergrowth.

When painting a river scene, I always leave the actual water until the very last when everything else has been put in. This way, you know where all the reflections should go. With wider expanses of water such as lakes or estuaries, you'll find that weather conditions are the governing factor. I've often looked across Loch Lomond, where I teach, and seen all the mountains reflected in the water. Two minutes later, a breeze may spring up and they will all disappear.

In coastal estuaries, you rarely see a distant reflection because of the sea breezes. However, nearby objects such as boats or posts will, of course, reflect, except in extreme condi-

tions. Do remember also, when painting larger stretches of water, to paint in cloud shadows. These will add interest to an otherwise plain surface.

Let's take a look now at fast-moving rivers with white water, foam and the occasional waterfall. It will repay you to spend a few minutes before you even take your paints out, to look at the scene quietly through half-closed eyes. What at first seems to be a complete chaos of random lights and darks, seemingly impossible to paint, will soon resolve itself into a steady pattern. Remember, too, that even here there are stretches of relative calm where objects can be reflected. Understatement is the thing and will be much more convincing. Even rocks – an essential part of such a scene – should be reduced to a few and be made smaller as they recede into the background. Here, too, it's essential to contrast the hard, sharp rocks against the soft, fluid texture of the water. It all adds to the excitement.

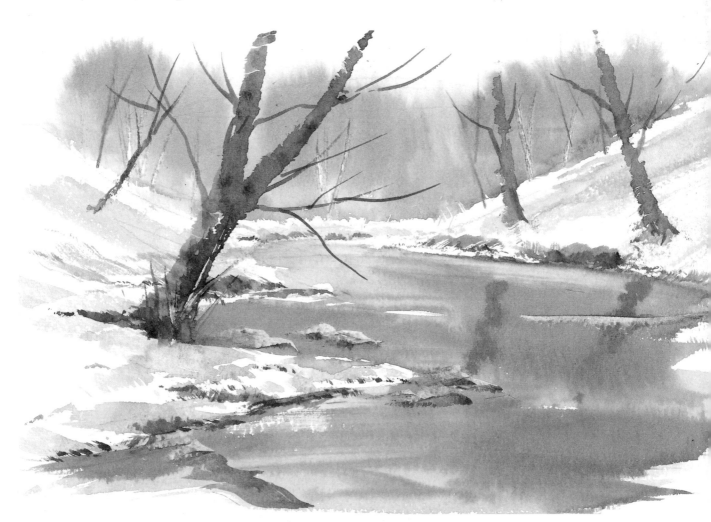

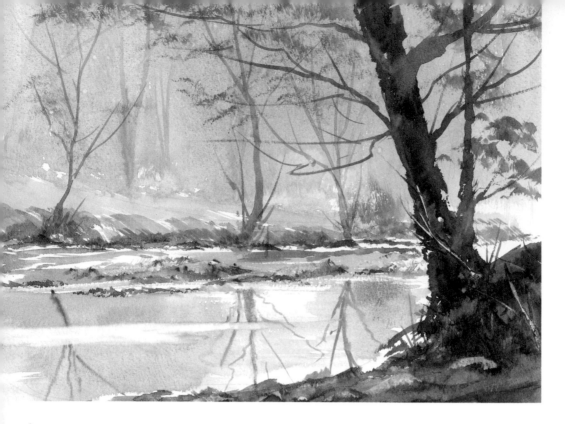

Above
This river scene was painted on a misty day in autumn. The background woods needed only a simple wash of light red and ultramarine to produce the mauvey haze, finished with a few wet-into-wet rigger strokes. The picture is framed by the 'L' shape created by the tree and foreground bank.

Right
I love this sort of subject. The faster you paint then the better they seem to look. I completed this in about ten minutes. It's of a fast-flowing river in Tennessee (yes I've even run a workshop there!). There's a strong contrast between the wet-into-wet river and the sharp, hard rocks which were painted with the 1in (2.5cm) flat.

You'll sometimes see a water painting which is monotonous and boring. This is because the artist has settled on a colour for the water and painted it in without variation. Every stretch of water needs variations of colour to give interest and excitement. In the seascape on p80, for example, the water varies from pale blue to grey where there are cloud shadows on it, through to pale green in the foreground shallows, dictated by the seabed underneath.

When you're painting rivers, as on p82, put in the slight variations of colour given by the reflected background foliage. In rough water, too, the contrasting area of dark water should also vary in colour. You should be able to see this in the painting below.

With river scenes in winter that depict snow, you'll need to darken the colours of the water to throw up the snow. Above all, do avoid overworking your picture; for instance, don't put in masses of little ripples. Understatement is the key to success!

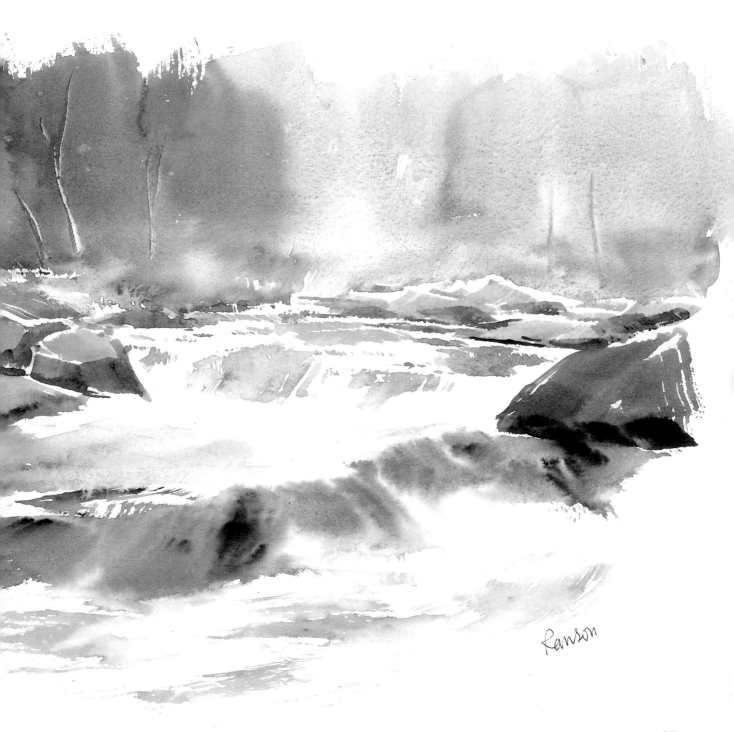

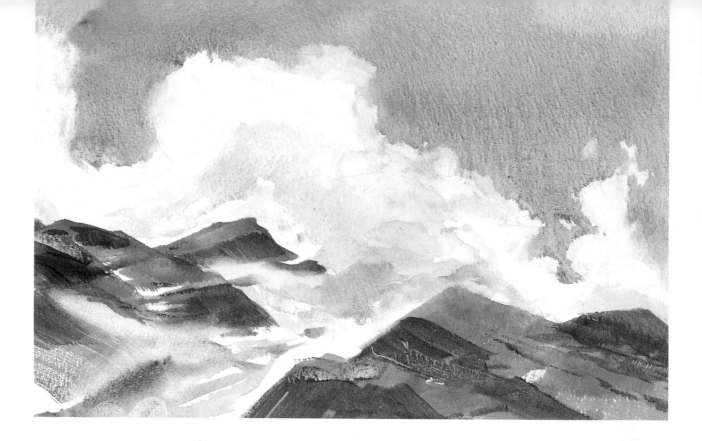

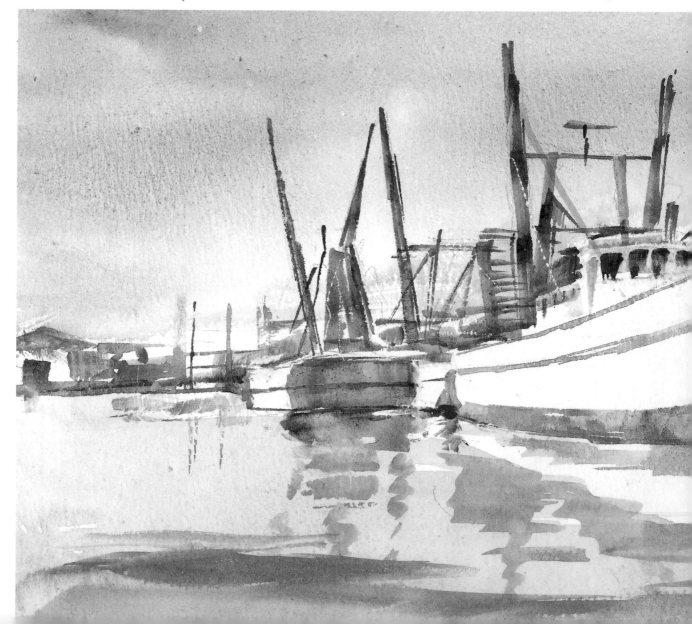

Opposite

Left is a sketch of a wave breaking on rocks. The task here was to indicate the soft but powerful foam to contrast with the hard, unshakeable rocks. Don't forget that the rocks too need to be varied in colour, they're never just grey or brown.

Below

This is a painting of fishing boats at Fort Myers in Florida. Here too I want to point out the variation and graduation of colour on the side of the fishing shed and even on the back of the smaller boat. This all helps to create interest.

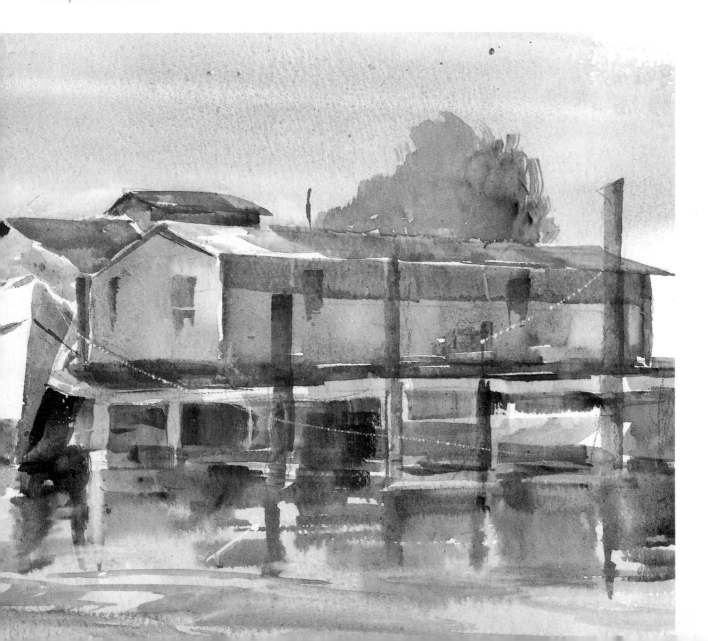

COLOUR

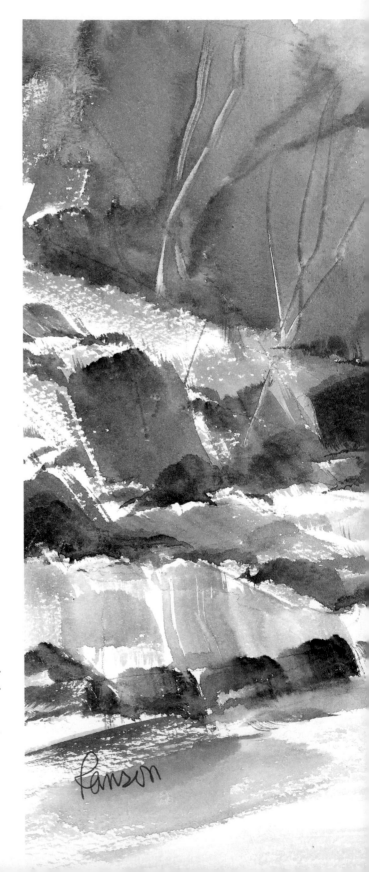

Colour can have an enormous effect on mood and atmosphere in a painting. The same picture painted in different colours will produce an entirely different effect and can be very useful to convey the different seasons. By using warm and cool colours, a painting can be given a great sense of depth and recession. Any artist, by his choice and use of colour, can express his personality in a very revealing way.

Just as a solid object has three dimensions – length, width and height – so too does colour – hue, value and chroma. Hue is the characteristic by which we are able to distinguish one colour from another – ie, yellow, blue, red and green. Value is simply the lightness and darkness of any colour. If you take red as an example, you can move through deepest plum to the palest pink. Chroma means the brightness or dullness of the hue – in other words, its intensity. Chroma shouldn't be confused with value which is only concerned with the lightness and darkness of a hue.

The following is a brief explanation about warm and cool colours. Warm colours are associated with earth and fire – red, orange, yellow and brown and the various mixes which these produce. Cool colours are blue, purple and anything which has blue in it, and are mainly associated with blue skies and cool water. Greens are neutral colours but can be warmed by adding yellow or cooled by adding blue. I use this technique extensively in my paintings to obtain distance in landscapes.

Complementary colours are colours which are opposite to each other on the colour circle. They have the effect of heightening each other and, once understood, this factor can be of great use in a painting. Remember, too, that if you mix two complementary colours, the opposite will happen and each will become more dull or greyer – this is very helpful in mixing beautiful greys. It is much better to do this than to use watered-down black, which looks dead.

I've tried to make this painting exciting by the use of warm and cool colours in a wet-into-wet background. Their interplay seems to make the background sing. Again, note the variety of colours in the rocks, their surfaces being indicated by fast brush strokes with the hake. The use of the white paper is also important.

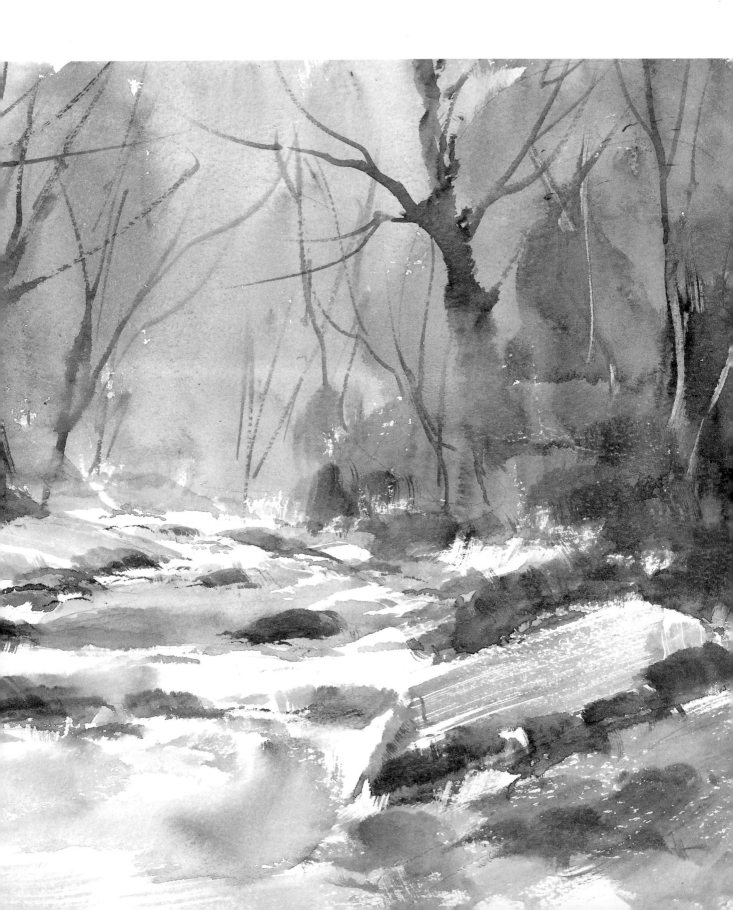

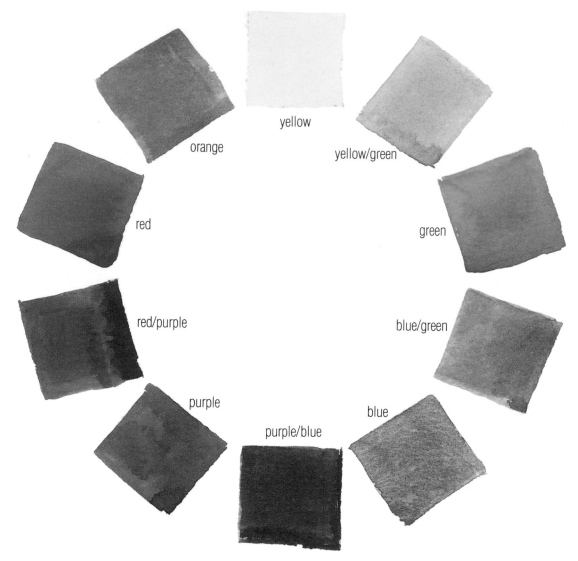

One of the major factors which divides the beginner from the advanced painter is the use of colour. A beginner will paint a field the same colour green all over, while an advanced painter will move from a cool green in the distance to warm rich green at his feet. When he puts in the immediate foreground, this too will be varied in temperature and tone to keep the viewer's interest and to avoid monotony. Two other examples are the wall of a shed or a building in Venice. In both examples, the experienced painter will provide a rich variety of colours. By contrast, the beginner will say that is a brown shed or a fawn wall and paint it on as he would emulsion on a wall with no thought to variation. It takes experience and practice to identify this range of colours in a subject, but even if you can't see them in reality, they should be used, albeit with discretion, to beautify your painting. An artist is an entertainer and it is his or her responsibility to keep the viewers entertained and not to bore them to death!

I should like to make one point very clear. So many artists are lured into art shops to buy tubes of colour with exotic-sounding names which they hope will make their paintings into masterpieces. You've probably heard on the art society grapevine 'You must try "rose pink genuine", it's wonderful'. You're led to believe that they're unique hues, but they're not. Every hue can be fitted in to the ten broad categories shown here. Basically, you can lighten any of these by adding water or darken them with any darker colour. A colour can be as bright as when it comes out of the tube, or softened by adding its complement. As I explained in Chapter 2, I deliberately keep my own colours to seven. For example, I don't have any made-up greens. I find, too, that I can use these seven colours anywhere in the world.

This is a modest little scene on a sea shore, but it can be increased in stature by the imaginative use of colour. Colour which is not immediately discernible in the scene itself. Look at the difference between the foreground sand dunes and the more distant beach. Never forget that it's the painter's job to entertain, and to do that you must avoid monotony.

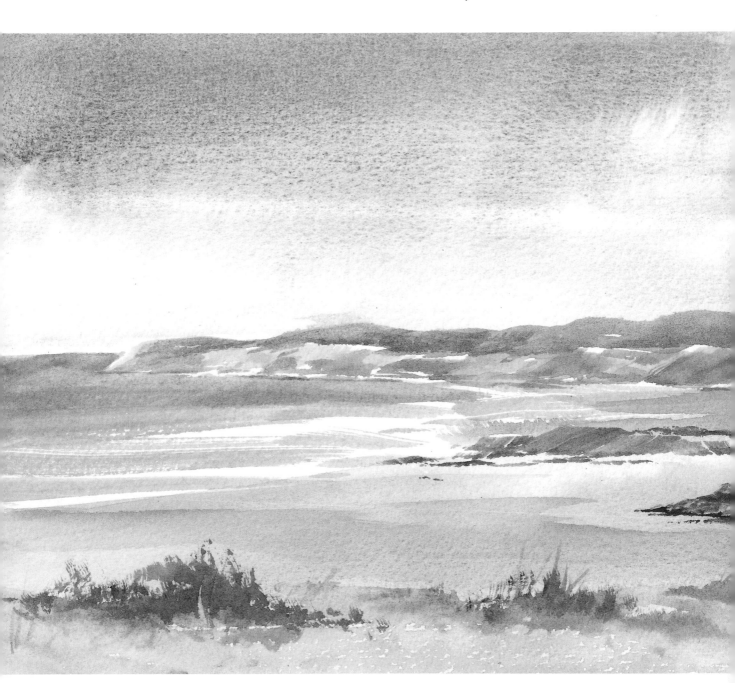

DISTILLING THE SCENE WORLDWIDE

I can't state strongly enough that this section is not about how to paint watercolours from photographs. In fact, a large proportion of these paintings were completed before I took the photographs. However, thousands of artists do work from photographs, regardless of the fact that they have been told by the powers that be that they shouldn't! Certainly, simply mindlessly copying photographs is a sterile exercise, giving little opportunity for the artist to show his or her personality or intellect. However, the procedure I've tried to show you in the following pages should be used whether you're painting on site or in a warm studio.

So we start with first thoughts on the scene – how it affects you mentally. Secondly, we look at what design changes need to be made, including what to reject and how to manipulate and possibly alter the remaining objects to make the picture more entertaining and satisfying.

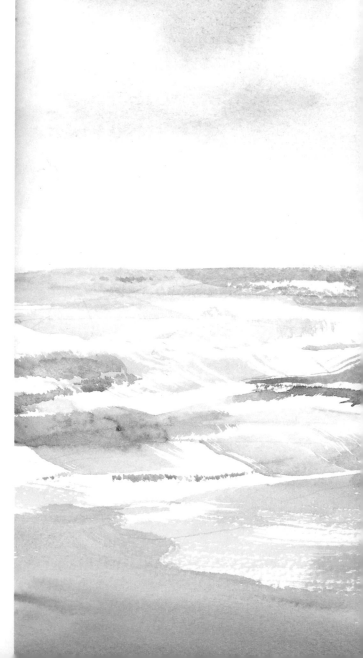

Then we move on to painting the picture, altering tone and colours where necessary, especially when applying various colours to flat surfaces to avoid boredom. Finally, you will learn how to avoid possible hazards in each particular subject. Overworking is one of the major problems. Study each spread carefully and use the four factors when doing your own painting.

This scene was enormous fun to paint. Notice the change in value and colour between the distant and foreground rocks and the use of quick, strong directional strokes to indicate the waves and beach. A quick stroke is always more exciting to look at than a slow one.

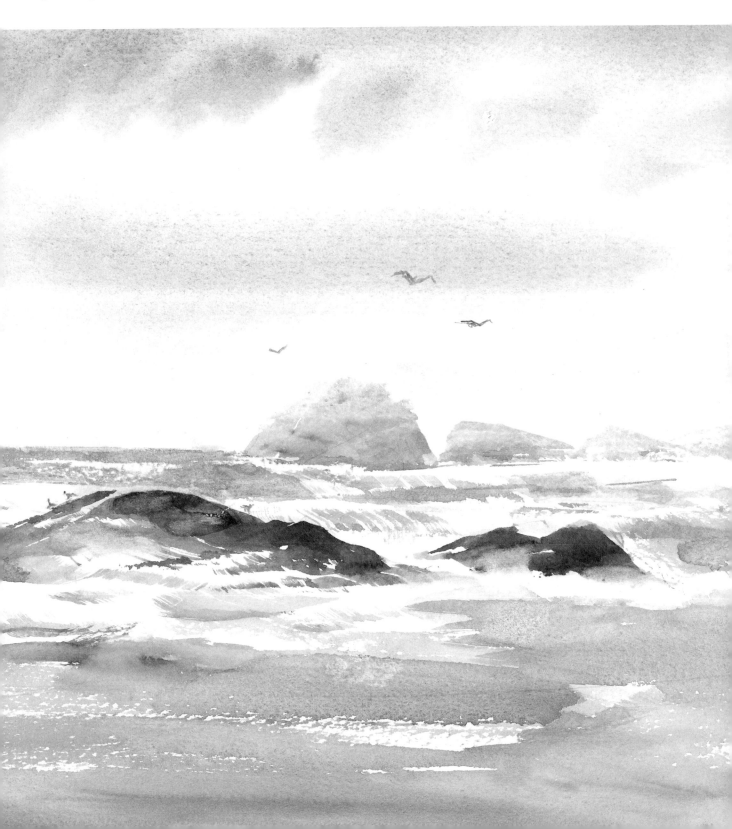

Kichapoe River, Wisconsin

• FIRST THOUGHTS •

Sunlight and shadow in a kaleidoscope of warm and cool greens. Sounds of rippling water and bird-song. This sort of subject always fills me with adrenalin – it is without doubt my favourite type of scene.

• DESIGN CHANGES •

I chose a vignette design so the white border would add extra sparkle. Because there is virtually no aerial perspective in this shallow depth of field, the river has the job of taking the viewer's eye into the painting. Therefore I strengthened the back line of the river and made the dark clump of brush the focal point.

• PAINTING THE PICTURE •

This began as a wet-into-wet for the whole of the background and some of the middle ground. First I used a thin wet yellowy-green to lubricate the surface, then darker thicker greens were dropped in almost immediately in patches. As this was drying, I added the tree trunks and rigger work along with fingernail scrapes. Next I painted the foreground banks in warmer, richer and more contrasting colours. The focal point, which I pre-planned, was untouched white paper and here I put in the darkest dark calligraphy. The river was painted in a very pale blue wash and immediately the reflections were added with dark green vertical strokes on this wet surface. Finally, the foreground framing of foliage on the left completed the picture in rich dark green.

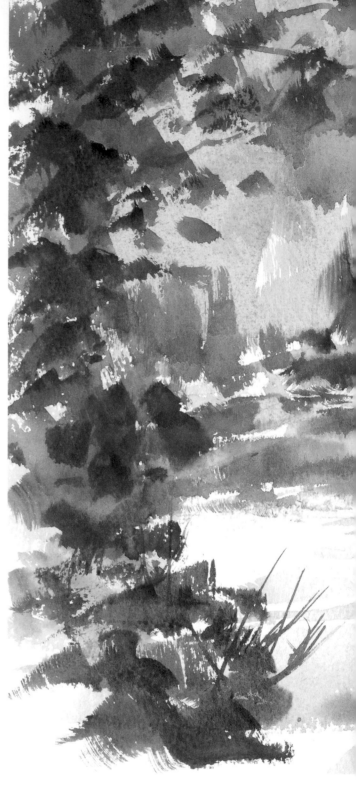

• POSSIBLE HAZARDS •

This subject offers a terrible temptation to overwork the busy foliage. I did exactly this in my first attempt. Just remember that spontaneity, to retain the freshness and sparkle, is the aim.

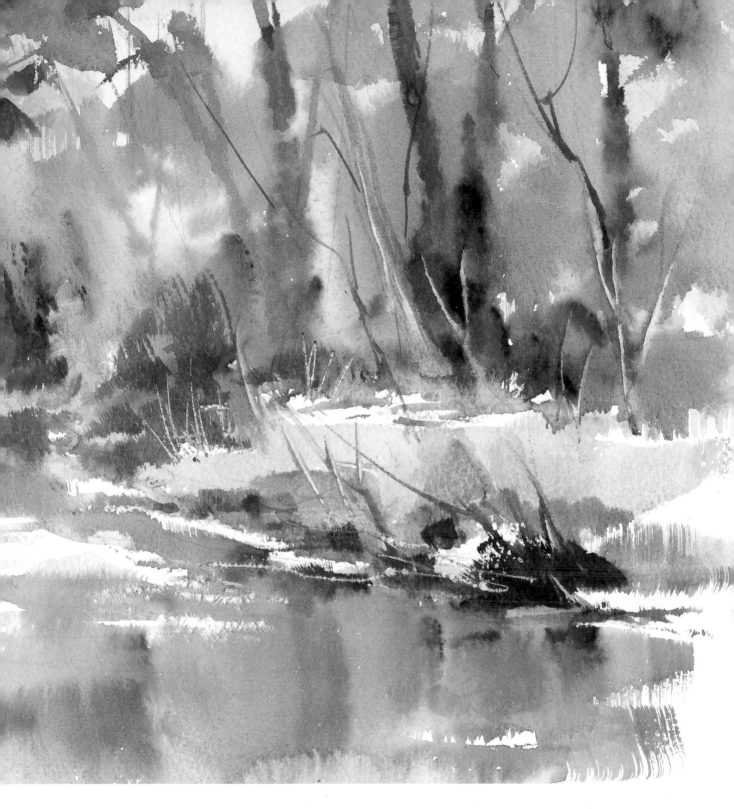

Milking Barn in Wisconsin

• FIRST THOUGHTS •

The red barn is almost an obligatory subject for watercolourists in the USA. Always painted in red, they are a disappearing symbol of rural America, being replaced by less romantic metal structures. I just had to throw my hat in the ring and give it a try.

• DESIGN CHANGES •

First the road going straight out of the picture must be corrected. Turning it from being a detriment into an asset, I used it to take the eye into the barn opening. The trees were placed behind the silo to throw it up with the roof. Three additions were made for interest: the hoist on a beam, the interior window to relieve the black hole in the barn and the figure for the focal point.

• PAINTING THE PICTURE •

My main task here was to introduce as many graded colours as possible throughout to avoid boredom. (The large area such as the front of the barn could easily become dead.) The planes of the wooden sides and roof were given a light wash, and strong warm and cool colours were added to the wet surface, painting around the figure. The usual cool to warm greens comprised the surrounding landscape. Note the added texture on the roof and barn sides, done at the end.

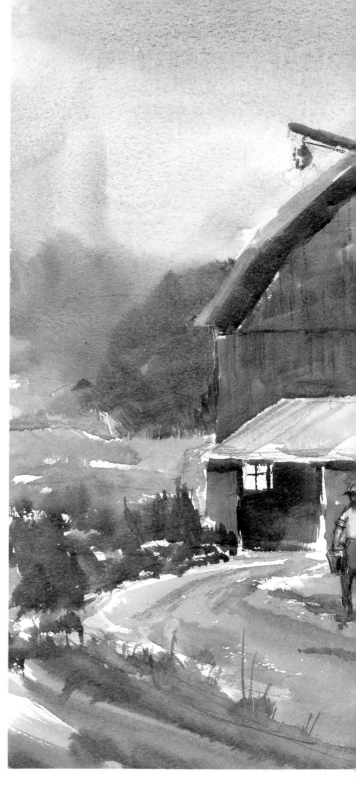

• POSSIBLE HAZARDS •

Try to avoid monotony of colours and making too literal a copy of the scene.

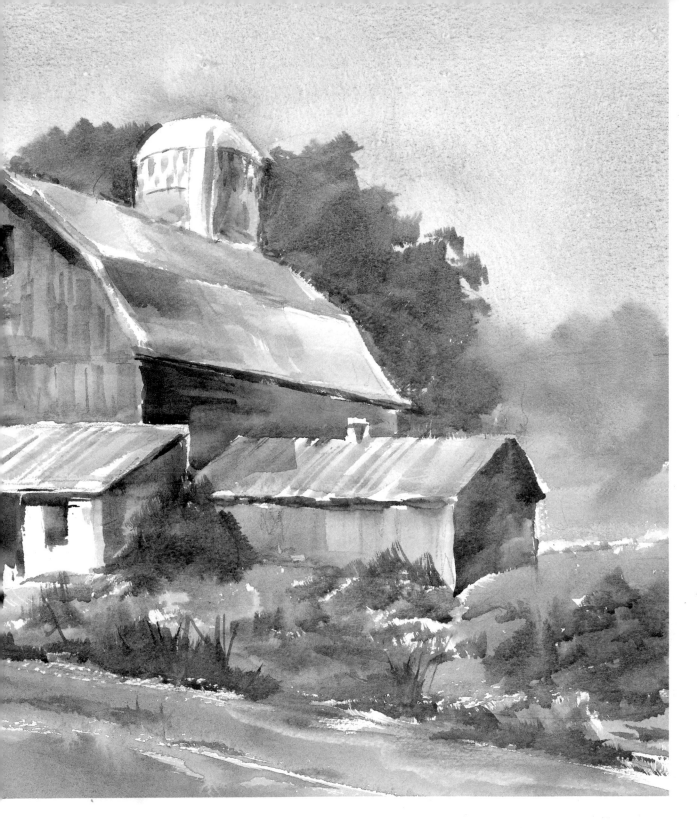

Grazing Sheep in Olive Grove

• FIRST THOUGHTS •

I've tried this type of scene many times in the past, on my painting holidays in the Greek Islands, and I've always found two main difficulties: first the texture of the olive trees, especially en masse, and secondly trying to portray a convincing flock of sheep. So you can see, I was fighting on all sides here.

• DESIGN CHANGES •

The patch of sunlit grass had to be modified in order to keep the viewer's eye in the painting. I've softened and simplified the background foliage and kept the values fairly close, except where contrast was needed to counterchange the sheep.

• PAINTING THE PICTURE •

I used masking fluid to cover the backs of the sheep, leaving myself free to produce a really free wet-into-wet background. As I've said, the colour of the foliage was difficult to portray – a very soft cool green. I dropped in the distant tree while the foliage was still wet but painted the foreground tree on top when the wash was dry. Removing the masking fluid, I painted the sheep wet-into-wet.

• POSSIBLE HAZARDS •

Overworking the foliage, the varying colours had to be merely hinted at so as not to distract from the sheep.

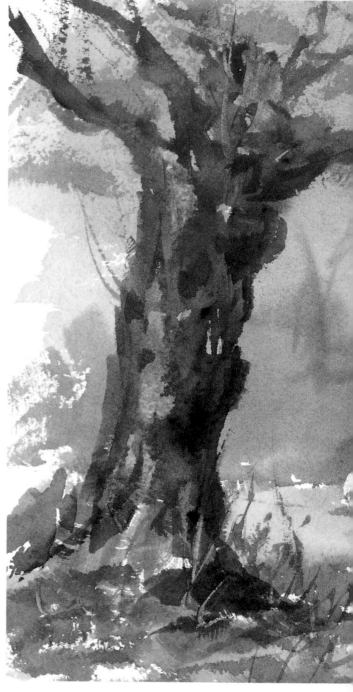

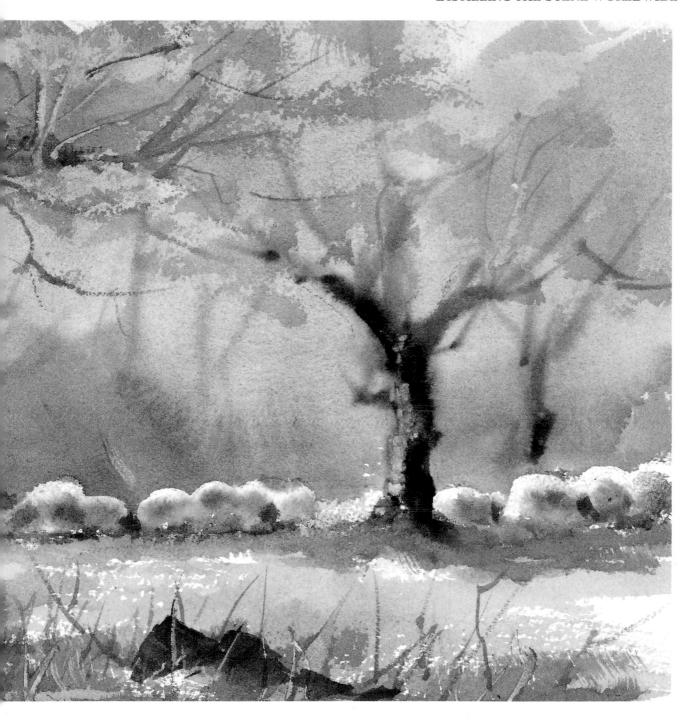

Oregon Coast

• FIRST THOUGHTS •

The Pacific coast of Oregon is very exciting, with high winds and crashing surf. One of the most difficult challenges to painting here is holding the easel down! The long sweeps of sandy beaches are broken by huge rocks and creeks emptying into the sea.

• DESIGN CHANGES •

The scene needed a proper focal point which I solved by placing four children on the beach. Keeping the figures very small emphasised the vastness of space. To clarify this focal point and add interest, I used the 'S' shape for the creek and this led the viewer's eye to the children with its direction.

• PAINTING THE SCENE •

After painting a simple sky, I indicated the waves with a minimum of blue-green strokes, leaving a large untouched paper white for surf. The beach was put in quickly using varied colour to avoid monotony. I warmed up the tan as well as it came into the foreground. Rocks and pebbles followed.

• POSSIBLE HAZARDS •

The usual problem of painting beach scenes may be encountered, in which all of the dark value is on one side, so that the empty space is boring and monotonous colour occurs.

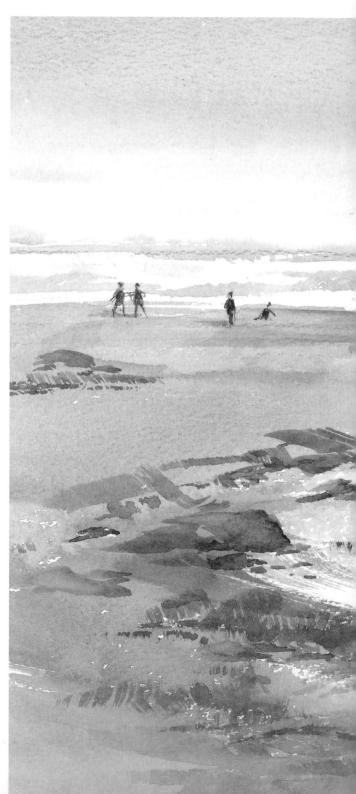

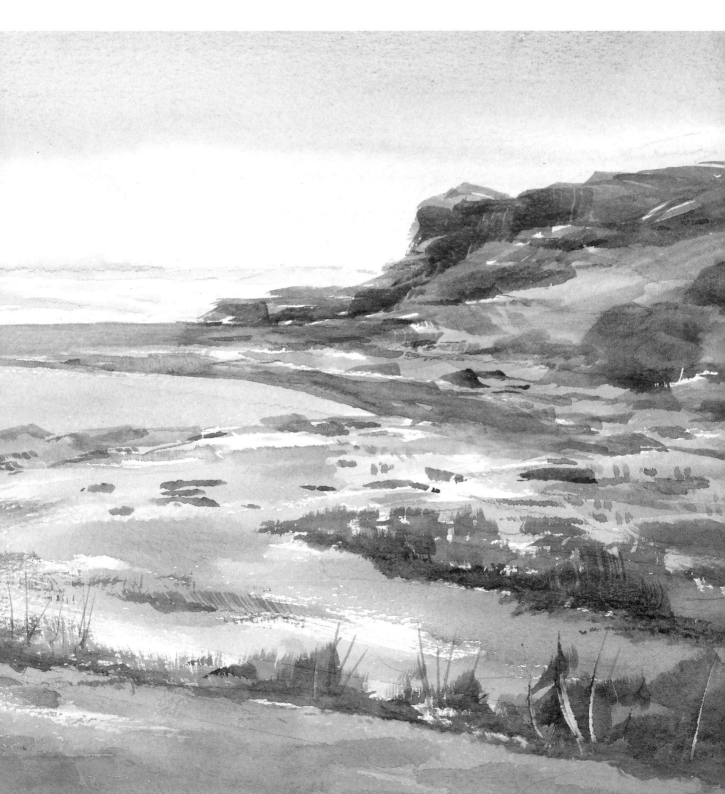

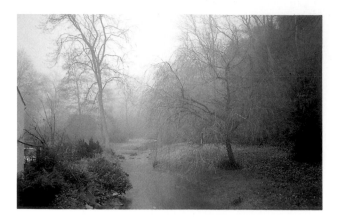

Mounton Brook

• FIRST THOUGHTS •

The tiny stream that runs through my garden is a constant joy to me (except when it floods!). The garden, seen here on a misty morning, calls out for a soft wet-into-wet painting.

• DESIGN CHANGES •

I played up the curvilinear shapes and pale colours to add as delicate and gentle a feeling as possible. Keep the warm colours predominant and, above all, keep it fresh with quick undisturbed washes. There's only a suggestion of my cottage in the distance as a whisper.

• PAINTING THE PICTURE •

I used paled raw sienna for the sky, quickly adding the cool greyed-down and diluted blues and mauves for the distant trees. Moving forward fast to ensure soft edges, I painted the middle-ground trees. Even these trunks must not be too distant. Fingernail scrapes of the damp reddish tone indicated the weeping willow branches. I was careful to leave white paper for the sparkle of the stream. To get the reflections here, I wet the surface with clear water before dropping in the soft reflections.

• POSSIBLE HAZARDS •

Overdoing the tree branch shapes, even though they are silhouetted, they could become overly busy with too many twigs. This could destroy the quiet peaceful feeling of the early morning garden.

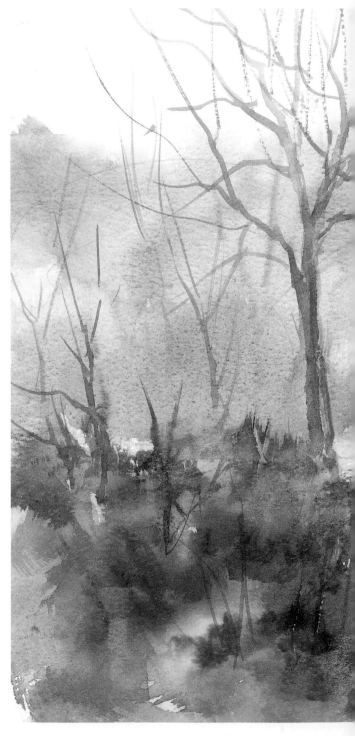

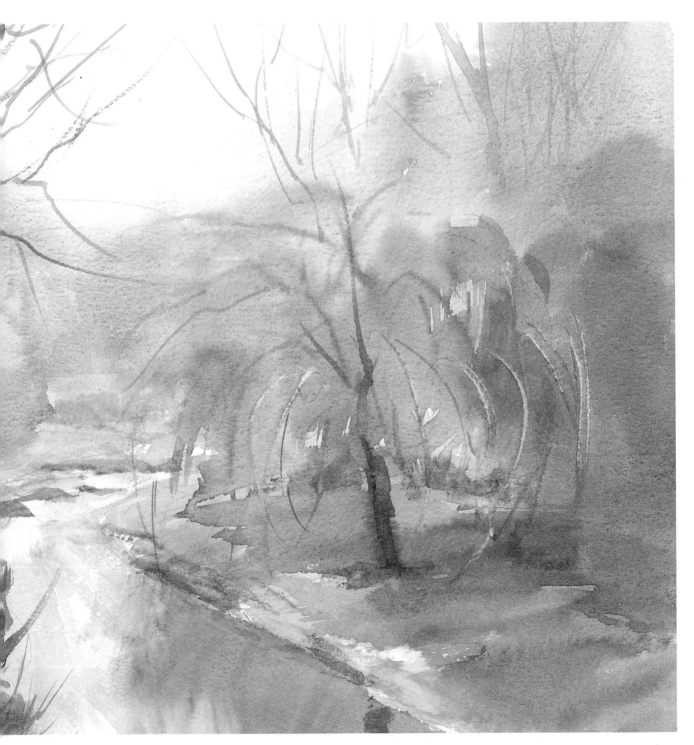

A Greek Alleyway

• FIRST THOUGHTS •

These narrow Greek alleyways climbing uphill are a delight to paint. The pristine white buildings and delicate shadows produce fascinating patterns. With such a close subject, however, the acute perspective can be difficult.

• DESIGN CHANGES •

The scene definitely needed a focal point, carefully placed just off-centre, and near the brightest colours so that it attracts the viewer's attention.

• PAINTING THE PICTURE •

This was a wonderful opportunity to allow the white paper to do much of the work. The shadows were put in with a mixture of light red and ultramarine and were painted in quickly to preserve their transparency – opaque shadows would ruin the freshness of the whole painting.

• POSSIBLE HAZARDS •

It would have been easy to make the figure the wrong size compared with the doorway. The shadow of the figure had to be linked with the main foreground shadow to avoid a bull's-eye effect.

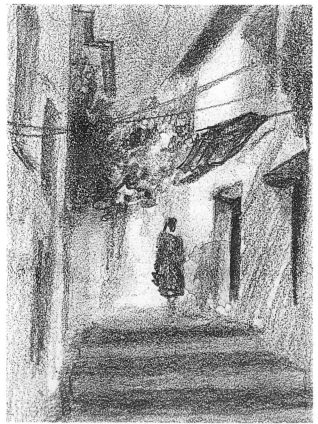

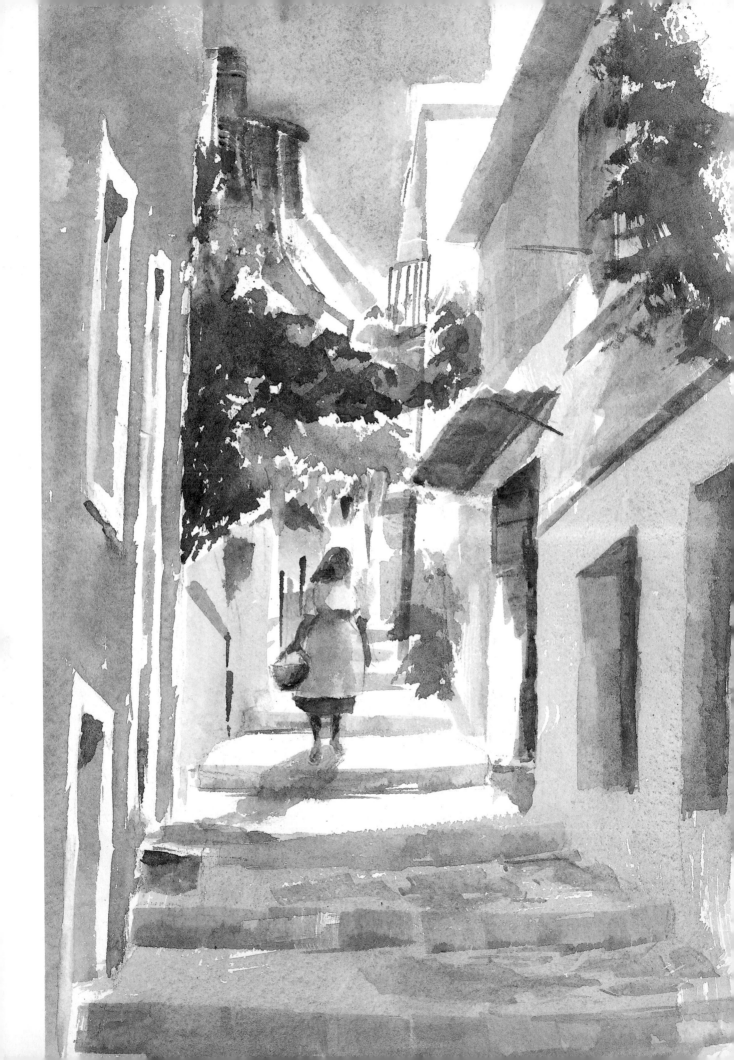

Bolivian Farmhouse

• FIRST THOUGHTS •

This is an exciting panorama with the clouds on the distant mountains and the unusual farm buildings for a focal point. There's an enormous depth of field here, too, which I enjoy painting.

• DESIGN CHANGES •

The main object is dead centre and the road leads out of the picture, both bad points. I therefore moved the farm to the right, got rid of the road and added trees for counterchange and balance. I stressed the horizontal lines to keep it a quiet, peaceful scene.

• PAINTING THE PICTURE •

First I painted the clouds wet-into-wet, blending into the mountains with Payne's grey and alizarin on a wet raw sienna wash. The mountains were painted in cool blue-grey colours, gradually warming up as they came forward. I wanted to spotlight the farm, so I painted it very contrastingly, adding more trees in warm greens around it. I brought the foreground forward by painting it in light red on raw sienna with fast sweeps of the brush.

• POSSIBLE HAZARDS •

In order to feature the farm, too much extraneous matter must be avoided. It's easy to overwork the foreground.

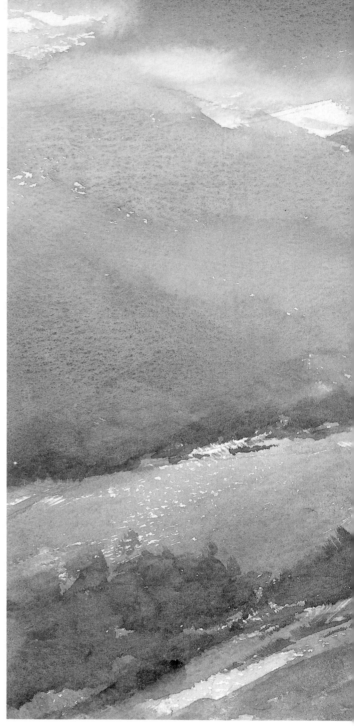

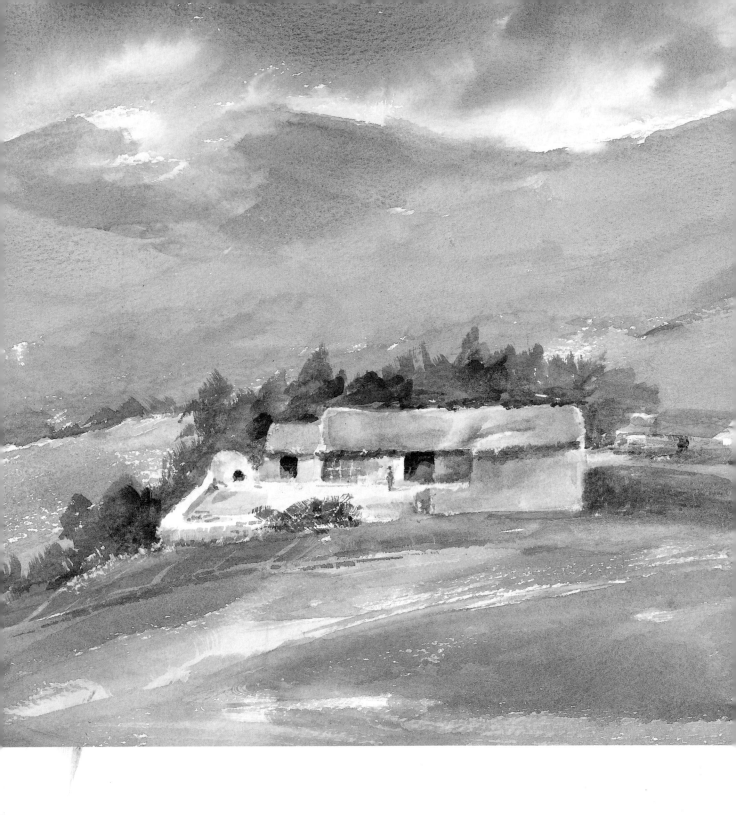

Greek Waterfront

• FIRST THOUGHTS •

I wanted to try what is known as 'checker-board animation' for some time and this scene presented an excellent opportunity. This is the town on a steep hillside of Poros, another of my painting holiday locations.

• DESIGN CHANGES •

I didn't really need a tonal sketch here as the aim was simplicity. The general pattern just needed to be painted in a flat manner with rectangular dominance and glowing colours.

• PAINTING THE PICTURE •

I wet the paper all over first and loosely glazed the surface with warm soft reds and yellows, letting them run together. When these were dry, I added the mid-tones for roofs, sky and trees. Finally, I put in the calligraphic marks for the windows and boats.

• POSSIBLE HAZARDS •

Never try to be too realistic and paint every house; keep the abstract all-over pattern, purposefully eliminating details.

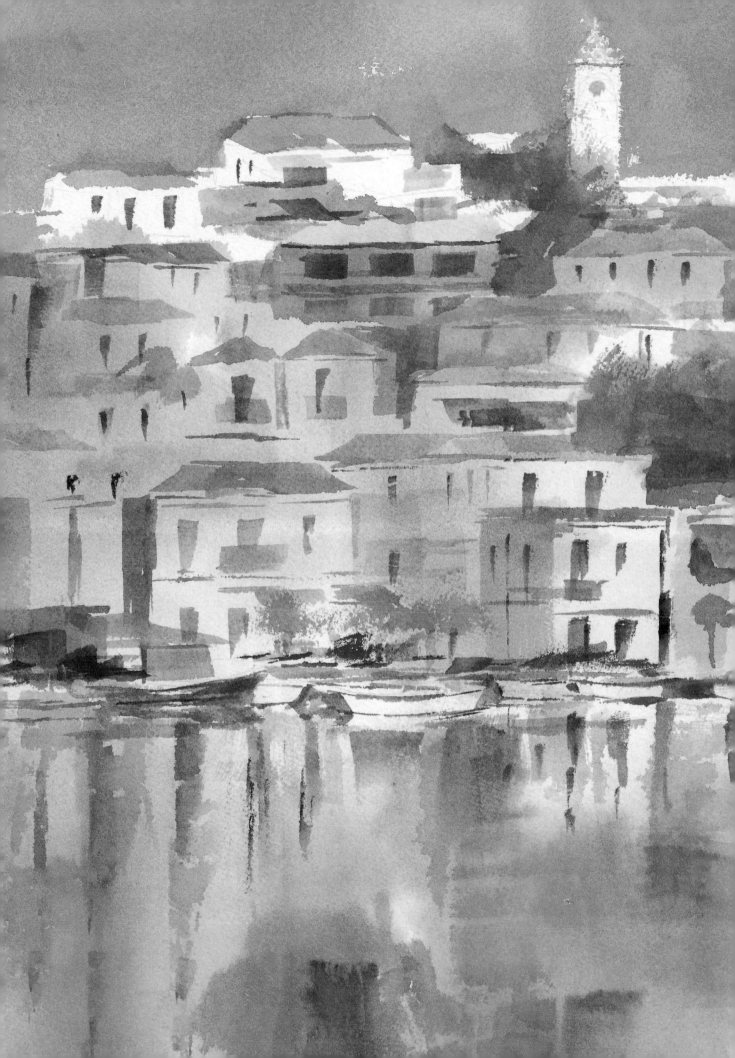

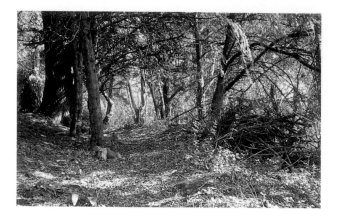

Woodland Glade

• FIRST THOUGHTS •

This charming little scene is another part of my garden. It was a complex mass of foliage and undergrowth, which simply cried out to be simplified.

• DESIGN CHANGES •

I've strengthened the feeling of lightness at the end of a tunnel and emphasised the path through the woods. Also, of course, I've eliminated much of the detail.

• PAINTING THE PICTURE •

This was started very much wet-into-wet. After the overall background colour was laid on, I put in many of the trees before the first wash had dried so that these soft edges contrasted well with the hard-edged trees, which were added later. I've tried to paint the whole scene as spontaneously as possible, to convey an atmosphere of peace and tranquillity, while attempting to avoid a totally green appearance.

• POSSIBLE HAZARDS •

I had to be very stern with myself to avoid overworking – there were so many twigs and branches begging to be included.

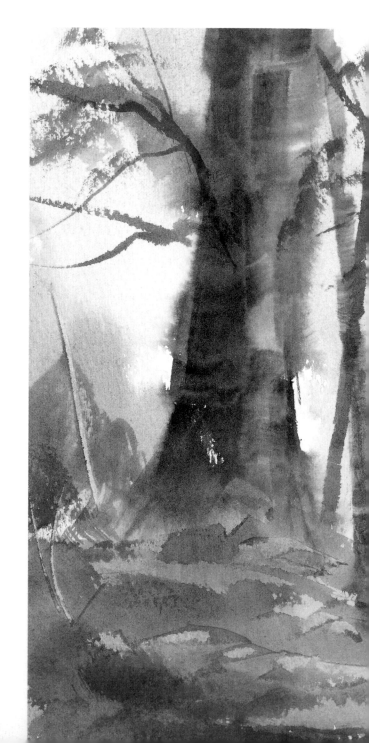

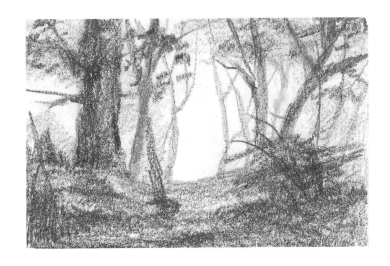

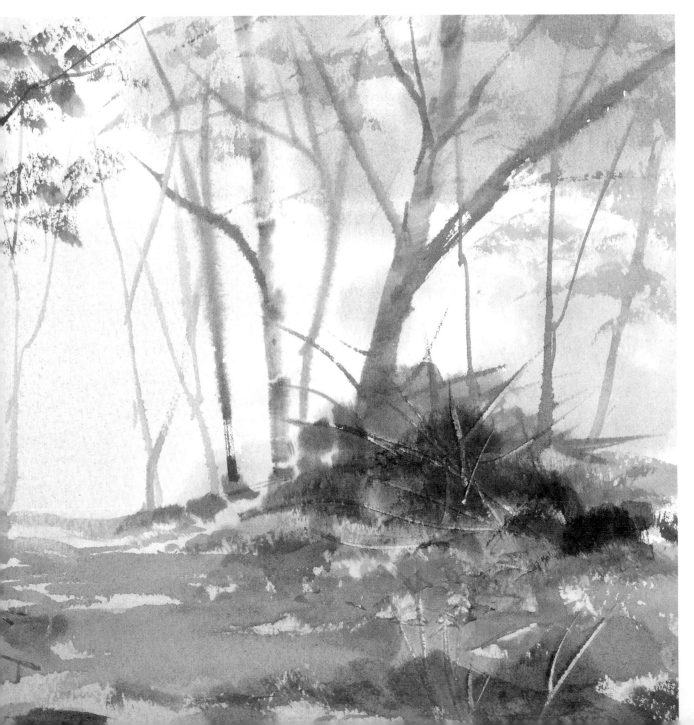

Porlock Weir, Somerset

• FIRST THOUGHTS •

This is my most favourite spot in England. Within 200 yards there is enough material for a month's painting. There's a row of thatched cottages, dozens of boats of all kinds and, as if that's not enough, the scene changes with every high and low tide. This is the scene from a bedroom window of the Anchor Hotel.

• DESIGN CHANGES •

I decided to lose some of the boats at the side to concentrate attention on the main group of yachts. I felt the composition would be improved by balancing the cottages with a big dark cloud to the right – so I changed the weather!

• PAINTING THE PICTURE •

First the sky: I worked quickly, using the hake, putting in a pale raw sienna wash, followed immediately with a patch of ultramarine on the top left. Then the big cloud: I used Payne's grey with a touch of alizarin crimson dropped in with a light dancing motion, and left it alone! The cottages, harbour wall and boats were then put in mainly with the 1in (2.5cm) flat brush. Only the first two boats needed to be authentic; the others are just dashes and white paper. Finally, the water was indicated and the reflections which were wet-into-wet. I left out all the rigging, putting in only one or two scratches with a Stanley knife blade.

• POSSIBLE HAZARDS •

There is the temptation to include too much detail in this busy scene. Using the 1in (2.5cm) flat prevents you from trying to put in every window frame! It is also tempting to cover up all the white paper.

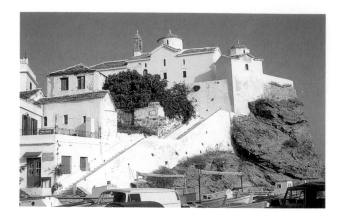

sienna, the shadows being added water with a mixture of ultramarine and light red.

• POSSIBLE HAZARDS •

Avoid leaving too much clutter and overfussing the scene.

The Citadel, Skopelos

• FIRST THOUGHTS •

I've spent many happy hours here on this tiny Greek island. This particular scene is a constant challenge, presenting a strong visual pattern.

• DESIGN CHANGES •

As you can see from the photograph, the base of the citadel is surrounded by a clutter of cars, boats and trucks, which rather takes away the romance of the scene. I therefore had to eliminate this conglomeration. The tonal pattern of this scene was so strong that it needed very little alteration, as can be seen from the tonal sketch. All I had to do was to add a strong dark shadow to the foreground for extra drama.

• PAINTING THE PICTURE •

The tricky bit was to get a strong yet spontaneous sky which would pick out the profile of the building. I must admit to using some masking fluid here, something which I rarely do. Most of the buildings were left as white paper with occasional touches of warm colour to indicate the shadows. The surfaces of the rocks were portrayed with directional strokes of the hake, varying the colour to avoid monotony and remembering to counterchange the tops of the boats. I used a corner of the 1in (2.5cm) brush to indicate windows, gutters, steps and boats, using the minimum of strokes. Finally, the figures were added with the rigger to show scale. The first wash for the warm foreground was put in with a mixture of light red and raw

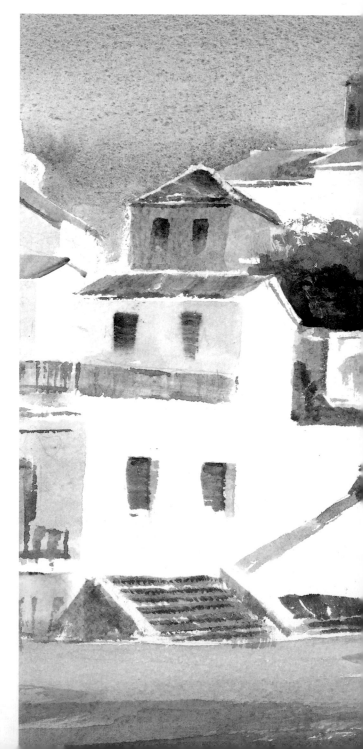

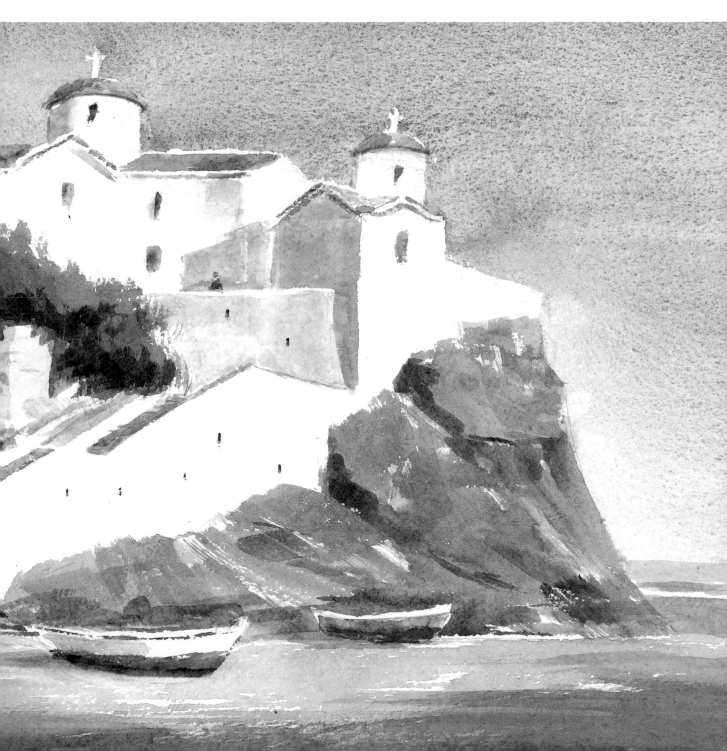

Piraeus Docks

• FIRST THOUGHTS •

Many's the hour I've waited in this harbour area of Athens for a hydrofoil boat to the Islands. An unusual subject for watercolour, the crane offers a strong vertical pattern with rich dark colours which form a background for the busy activity.

• DESIGN CHANGES •

Simplification is the name of the game here, with just enough detail to maintain a busy atmosphere. The focal point was planned around the lone figure on the lorry, framed by the base of the crane.

• PAINTING THE PICTURE •

The strength of this machinery was best expressed by a vertically dominated painting, so even the sky was painted vertically. I tried enriching the darks as well with lots of varying colour. I kept them neutral, however, to play off the rich orange on the containers. Notice that the brightest orange and only pure white were saved for the focal point.

• POSSIBLE HAZARDS •

Mainly I had to avoid the dead, flat colours in the darks and too many directional lines taking the eye off the painting.

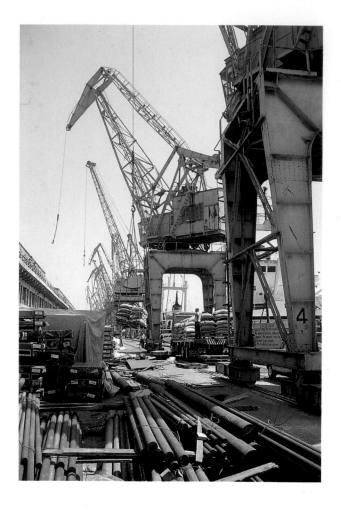

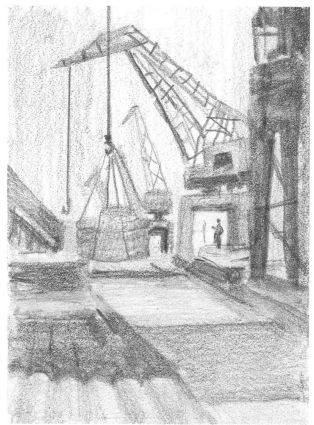

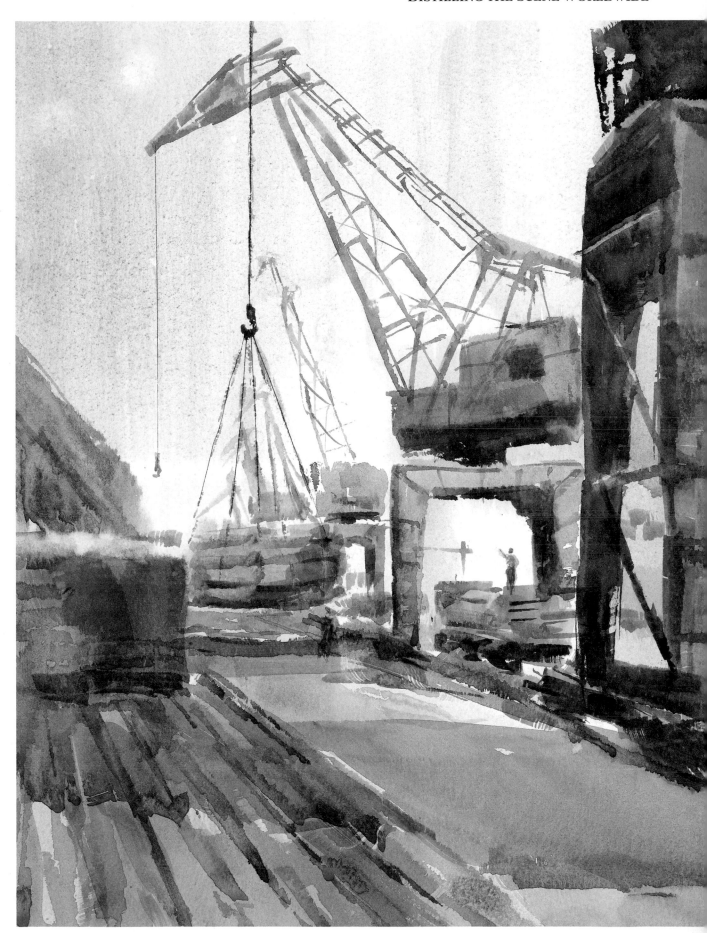

Mont St Michel

• FIRST THOUGHTS •

This scene in Brittany is magnificent, even awe-inspiring. It is an island at high tide, surmounted by its spire pointing heavenward.

• DESIGN CHANGES •

First I painted the island off-centre to get away from the too formal balance, thus making a more active composition. I gave it more drama and balance by adding a strong cloud shape which goes behind, forming a backdrop. The lone boat in the foreground provides a simple object to contrast with the grand scale of the Abbey of Mont St Michel in the distance.

• PAINTING THE PICTURE •

I painted the sky first using Payne's grey and alizarin crimson for the big cloud shape. I used a variety of warm and cool colours to pattern loosely the town and abbey, trying to keep it as random as possible. For the foreground I used sweeping strokes to lead the eye in and repeat the curve of the cloud, adding texture with a dry brush afterwards.

• POSSIBLE HAZARDS •

Avoid too much detail in the treatment of the town – you need only provide an impression. The same advice applies to the boat – it shouldn't steal the show from the main object.

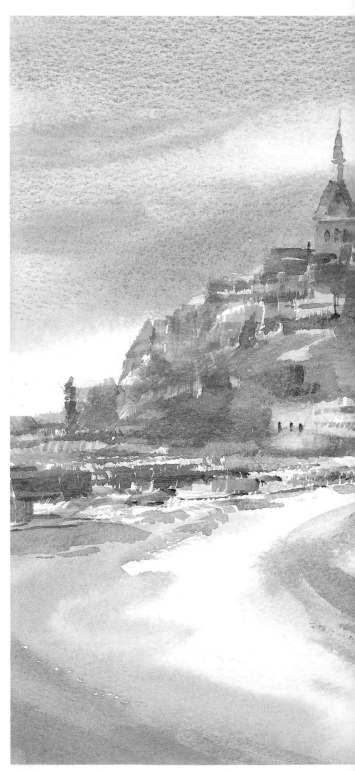

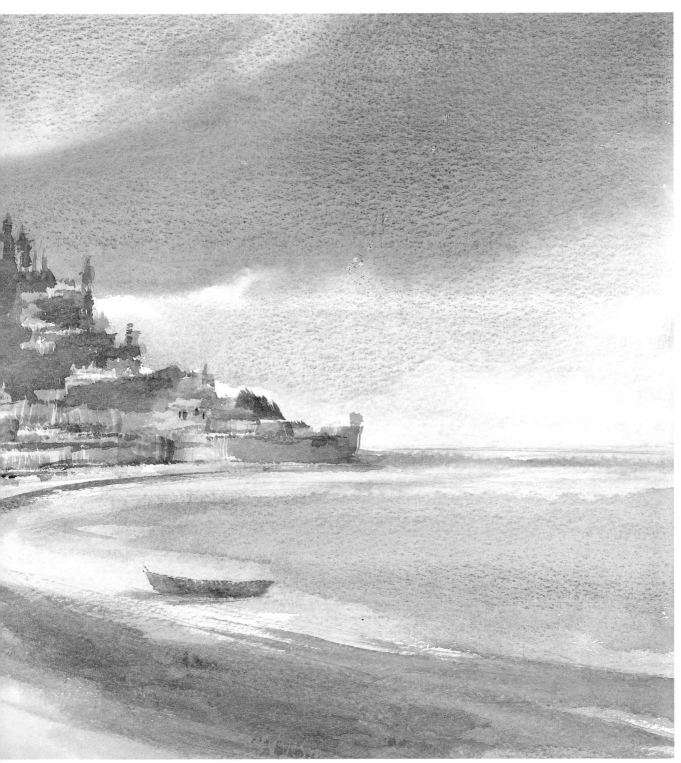

Skopelos Harbour

• FIRST THOUGHTS •

This is one of the Greek islands where I teach. The town itself presents an almost 'wedding cake' appearance as the houses rise up the hillside, punctuated by trees. The foreground boat is built in the traditional style and the two together give a true feeling of the island.

• DESIGN CHANGES •

I changed the direction of the boat so that the curve of the bow leads the eye back into the picture. The weight of tone was too heavy on the left and moving the boat helped to correct this problem as well.

• PAINTING THE PICTURE •

After painting the sky with my usual ultramarine blue over a very wet raw sienna wash, I painted around the white shapes of the buildings. I utilised the white of the paper to the utmost, just using light red and raw sienna for roof colours and a medium green for the trees. The harbour was painted wet-into-wet, reflecting the town while leaving untouched paper for the boat. Finally, the boat detailing was completed on the dried surface.

• POSSIBLE HAZARDS •

Regarding the town, resist the temptation of paying too much attention to detail – don't count the windows! Let the viewer's imagination fill in the gaps. Simplify the boat to large shapes as well.

118

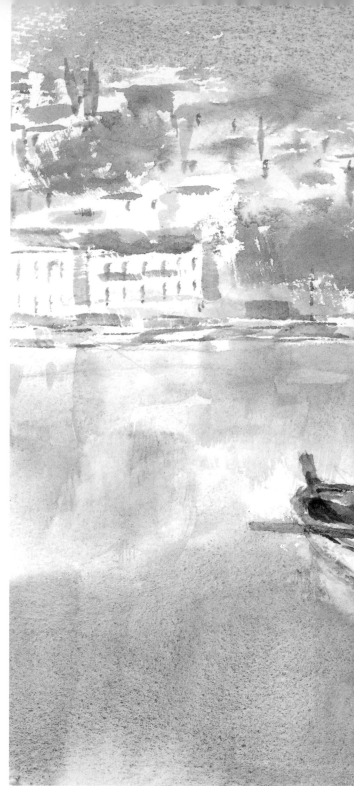

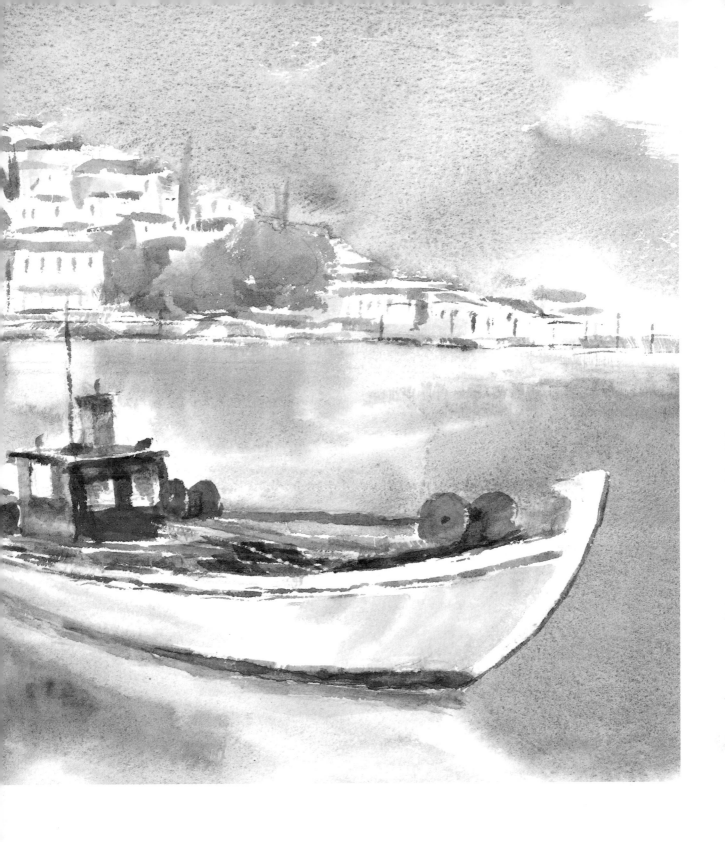

WHAT OF THE FUTURE?

Yxou can't stand still with watercolour painting – you either move forward or you stagnate. I've learned my craft, and am still learning, from those masters of distillation such as those whose work I've shown in Chapter 1. Having never attended an art school myself, the study of these works has been my education. I've tried not to base my style on any one artist but to use the mental and emotional responses they've stirred in me to emulate their thinking and to create my own style. But where do I go from here? After all, hopefully I've got another twenty or thirty years ahead of me to explore new ideas and techniques. I could, of course, venture into the somewhat rarefied world of abstract painting, but this isn't for me. It would be fighting against my own personality and inclination. I feel that I always want to keep one foot firmly in the figurative camp but to push out its parameters, as did the French Impressionists early in this century. Here, too, you need role models to provide ideas and possibilities – if you like, the frontiersmen of watercolour.

Here, then, is the work of four artists, all of whom I am proud to call friends and who each in their own way are constantly pushing out the borders and whose work inspires me to extend my own possibilities.

Lawrence Goldsmith

I was thrilled by this man's work when I first saw it in his book entitled *Bold and Free*. This bestseller, which incidentally is his only book, sells in tens of thousands worldwide. When I started to teach regularly each year in the little town of Port Clyde, Maine, on my day off I would take a boat ride to the tiny island of Monhegan, which seemed to be populated entirely by fishermen and artists. Here it was that

I actually met Lawrence Goldsmith for the first time and visited his studio. They've become rather expensive visits as for the last two years I've come home to England with one of

MONHEGAN ISLAND by Lawrence Goldsmith

his paintings. I find them truly inspirational. The freedom and looseness of his technique leave me quite breathless.

Goldsmith verges on the semi-abstract. The picture shown here represents the spirit of Monhegan Island itself with its pine trees, beaches, rough seas and mists – all incorporated in this one dramatic painting. Using large sheets of Arches rough paper, which he soaks first, he puts on loose washes in rich imaginative colours. As the paper dries, he puts in his spatter and later the calligraphy. It seems to me that his work occupies an area somewhere between the figurative and abstract. If you ever visit the island, you'll understand what I mean when I say that this is how it feels rather than how it looks.

Goldsmith's area is the one in which I would like my own work to be in the future. With this example over my fireplace, I'm hoping that his work will somehow permeate my own approach to watercolour. It will, of course, take time – you can't suddenly rush out one morning and produce this type of painting.

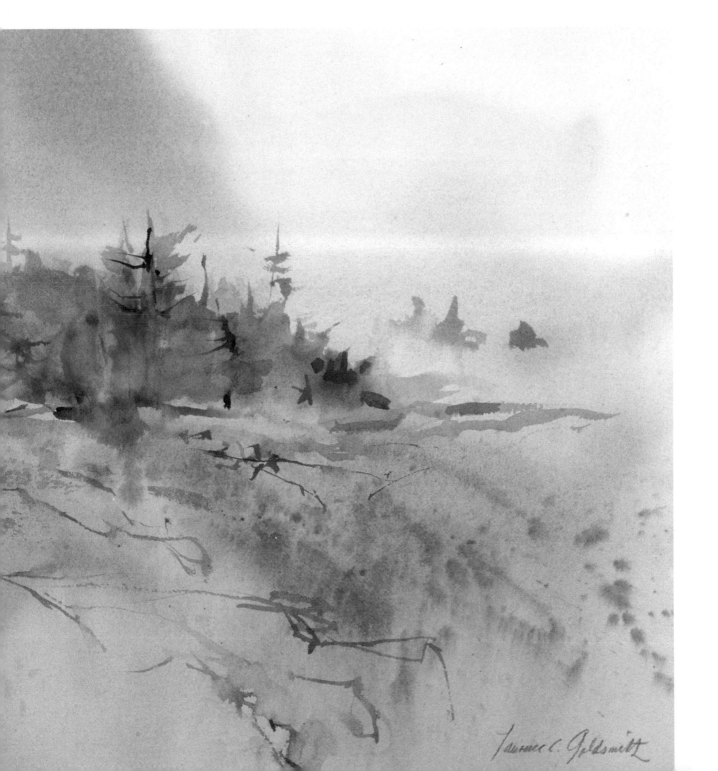

Claude Croney

I was introduced to Croney's work through his books. He is a master of the really well-designed and powerful watercolour, full of life and vitality. When I came to write *Watercolour Impressionists*, I was able to choose the work of artists I admired from all around the world, and Croney's work was, of course, included. He was so pleased with my presentation of him that he asked me to stay at his house in the little village of Cedar Quay on the west coast of Florida. It was a memorable experience! He was a real Hemingway-type character and we soon became firm friends. I came home with the painting opposite, which is an excellent example of his work, being so full of rich vibrant colour and strength of technique.

Croney used to spend much time designing and composing a painting, but once he had made his decisions, he painted rapidly and with vigour – a true watercolour lesson in itself. Since meeting him, I've spent a much larger proportion of my time on the design stage and I've tried to pass the importance of this on to my own students. I also learned from him the use of rich colour in places where you wouldn't expect to find it. Sadly, Croney died recently through cancer and I hope that some time in the future I will produce a book about him as a tribute to a fine artist and friend.

AUTUMN WOODLAND by Claude Croney
This powerful autumn woodland scene is typical of Claude Croney's work. The fallen tree and its stump form a strong focal point, counterchanged against the rich woodland. He's managed to get an amazing variety of colours into the scene. This is a picture I'm very proud to own.

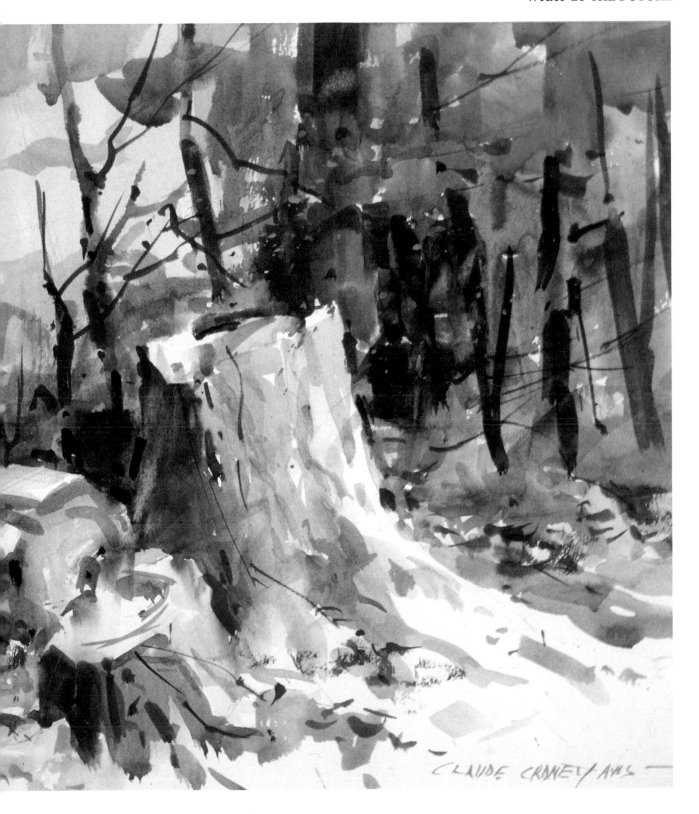

CLAUDE CRONEY/AWS

John Palmer

I came to know John Palmer's work by painting beside him at the Bristol Savages Club, the famous institution that was founded in 1909. Each Wednesday evening we would paint from imagination the subject written on the blackboard in front of us – a challenging test! I found John's work exciting, and was amazed by his dexterity and the looseness of his technique. His pencil work is completely original, quite unlike anything I had seen before. He learned his craft in the commercial studio of a tobacco company in Bristol, producing artwork for cigarette cards. One might expect that this would tighten the artist's approach, but this certainly wasn't the case with John. His work is free though controlled and utterly professional, and he seems to be able to work in any medium with a freedom I would give my ears to attain. He's a true impressionist – something I always find tremendously inspiring.

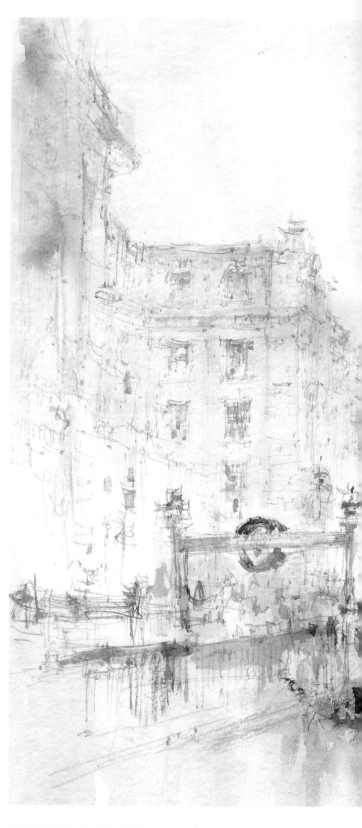

PICCADILLY CIRCUS by John Palmer
John Palmer has combined great strength with delicacy in this exciting portrayal of Piccadilly Circus. Without really putting in much in the way of detail, he's convinced the viewer of the authenticity of each building. Much of John Palmer's genius is knowing exactly where to stop, and in the way in which he takes the viewer into partnership.

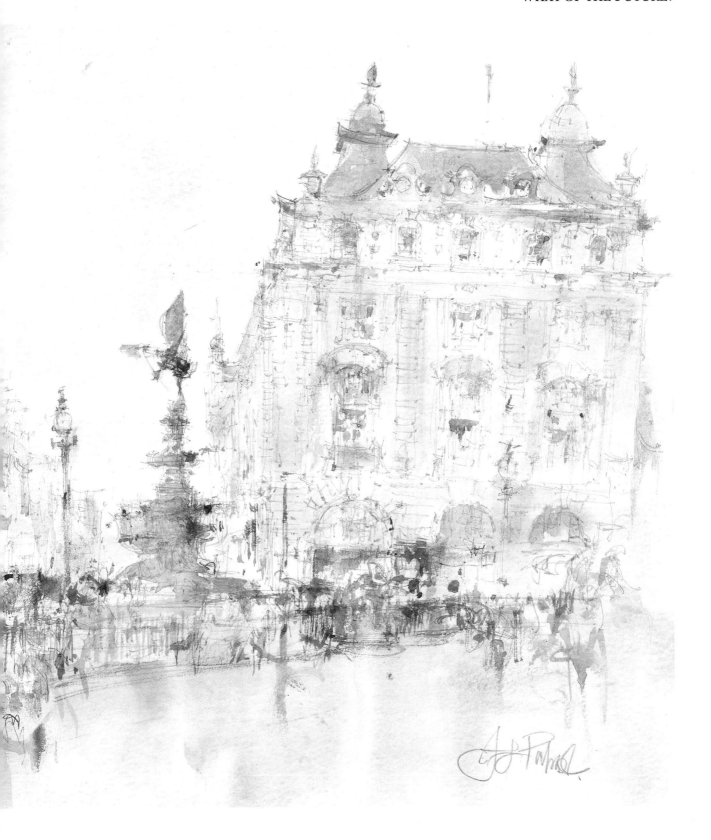

Frank Webb

Frank Webb learned his craft and discipline in the tough world of advertising. An intellectual, his approach to watercolour, which incidentally has influenced the work of many of his contemporaries, particularly in the USA, is unique. Respected and admired, he's been showered with national awards and has written numerous books. These books were my introduction to Frank's work, which I found so far advanced that I felt that I should never be able to catch him up. Although his work had a tremendous impact on me, it wasn't until I asked him to become a contributor to my book *Watercolour Impressionists* that I came to know him personally. In the design of his paintings, he abstracts his subjects to a very high degree. This requires a deep knowledge and a lot of paper! Frank thinks that having a large supply of paper is like having many tomorrows. He says he ruins acres of it in the pursuit of excellence, and always starts a new sheet rather than attempting to rectify a bad start.

Frank Webb has a deeply philosophical nature and an infinite capacity for hard work. For him the thrill is beginning a painting and his aim is brevity. He would like to complete a painting in just a single stroke if he could. One of Frank's statements is very relevant to this chapter: 'Most people judge us by what we've done. We judge ourselves by what we think we should be able to make tomorrow.'

All these four artists have given, and continue to give me, through their paintings, a feeling of elation and a spirit of expectancy, which gives me hope not only for my own future but for the future of watercolour.

UNTITLED by Frank Webb
I find the way in which Frank Webb uses such rich and varied colours really exciting. He's produced this painting in an almost kaleidoscopic manner to create impact. The two figures against the light striped building are the centre of interest. After this the viewer is left to explore the many changes in colour and tone. A real feast of artistic virtuosity.

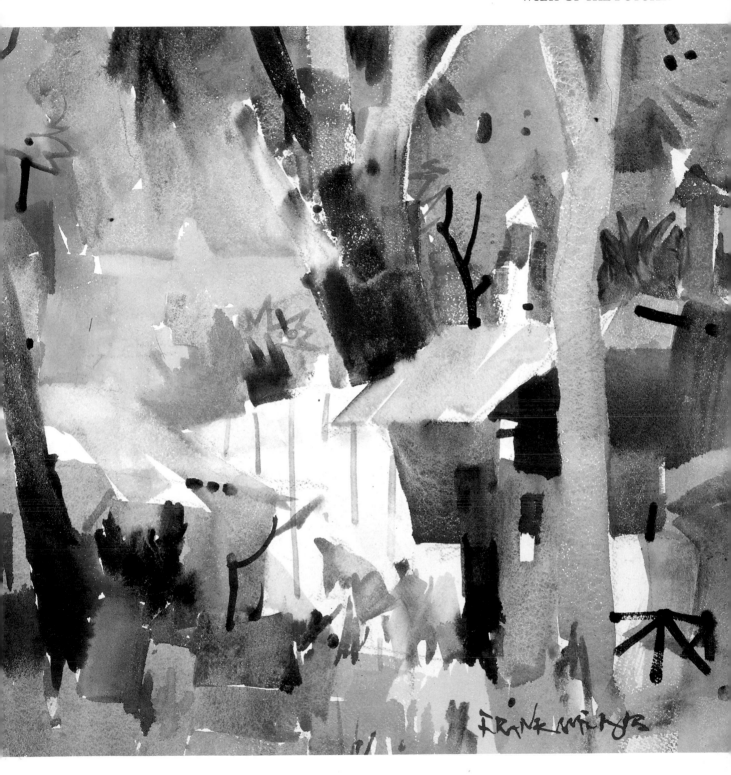

INDEX